VINTAGE HAND LETTERING

CREATE BEAUTIFUL FONTS WITH OLD TIME FLOURISH

LISA QUINE

PAGE STREET
PUBLISHING CO.

PAGE STREET
PUBLISHING CO.

First published in 2020 by
Page Street Publishing Co.
27 Congress Street, Suite 105
Salem, MA 01970
www.pagestreetpublishing.com

Distributed by Macmillan, sales in Canada by The Canadian Manda Group.

24 23 22 21 20 1 2 3 4 5

ISBN-13: 978-1-62414-986-3
ISBN-10: 1-62414-986-3

Library of Congress Control Number: 2019942902

Cover by Lisa Quine, book design by Meg Baskis for Page Street Publishing Co.
Author photo by Sharon Hughes

Printed and bound in China

DEDICATION

For Mark, my wonderful and profoundly supportive husband.

And to everyone putting in the work to be a self-taught creator, doer, maker, and artist.

CONTENTS

FOREWORD

I have had the pleasure of knowing and working with Lisa for several years. Lisa's work is unique. Somehow, it is both vintage and contemporary. It nods to the Old World and also to an exciting new age of illustration. My favorite works of hers are modern song lyrics ornately decorated as if they were straight out of the 1800s, gilded in gold and leaping from the page. They make you laugh and cause you to interact with and adore artwork in a way only lettering can. Lisa is an example of a modern artist who has successfully segued an age-old craft into a modern career. She has built a life for herself in which she is able to create art every day. She is a true "maker."

Who among us wouldn't love to wake up with Lisa's skill set flowing freely from our fingertips? She will urge patience and practice, and those words couldn't be truer. Some of us may be born with talent, but skill is an earned craft that rewards only those who give themselves the time to strive for it. Whether you are a hobbyist or a professional artist looking to add a new skill to your tool kit, I urge you: Savor the process. Take delight in the pencil shavings and the eraser smudges.

Lisa has taken years of technical, foundational, and on-the-job training, as well as her failures and successes, and boiled them down (like any expert-level potion maker) to a delicious, palatable concoction. She will teach you the history of these vintage styles and show you how to push the boundaries of the letterforms, one step at a time.

I hope this book and this wonderful author light a new creative spark inside you. I hope you relish each moment.

—**MAGGIE ENTERRIOS,** Illustrator

INTRODUCTION

If you're reading these pages, chances are you've dabbled in lettering or have an interest in getting started. I mean, why wouldn't you? Lettering is an amazing form of art that transforms the written word into an expressive visual experience that comes from your creative mind! I want this book to be a helpful resource that teaches you how to hand-letter in styles inspired by my favorite time periods in art and culture, like the Victorian era, art nouveau, and art deco.

These days, learning how to hand-letter in these gorgeous older styles can be tricky. If you started from scratch, you'd have to track down books from a hundred years ago on eBay or spend a ton of time researching and practicing on your own. This book contains ten different vintage-style typefaces with multiple variations of each, all taught by someone from our own modern age who has been lettering in these styles for seven years!

I studied graphic design in college and immediately fell in love with my typography classes, but I also had a soft spot for the foundational classes, like drawing and painting. I didn't know that I could merge the two together until I created an Instagram account after graduating and discovered the fascinating world of lettering. From there, I obsessed over practicing different styles of lettering outside of my full-time job in advertising.

Eventually I started posting my work and attracting some smaller projects as well as a modest Instagram following. The small projects grew into larger projects and even murals, until I was able to finally start my own business. I now have the privilege of speaking at conferences, painting murals, and working on vintage lettering-based projects—and what really helped me grow as a lettering artist was exploring my infatuation with decorative, vintage typefaces.

Vintage lettering and typography include some of the most beautiful and ornate typeface styles. Unlike modern calligraphy, lettering requires you to draw each letter, which takes a significant amount of time and attention to detail. When you're drawing the letters by hand, there's something meditative and rewarding about the patience required to sketch out each detail. Then there's even more satisfaction in seeing the words and layout come together after all your hard work.

This book is your one-stop shop when it comes to learning how to letter various styles within the vintage-inspired realm. The book relies on an easy step-by-step process of crafting all twenty-six letters of the alphabet in ten overall styles, each with multiple variations of that style within the chapters.

Each chapter follows the same formula to make learning the styles a breeze! First, we'll take a look at just a couple of letters and see how to draw them step-by-step. (Styles are much more digestible when you begin with only a letter or two.) Next, you're going to take what you learned by practicing those first couple of letters and draw the whole alphabet. And don't worry, there will be examples of each letter to help guide you—it's like taking a test, but you have all the answers! Finally, we won't leave you hanging with a bunch of letters. We'll apply that style to a hand-lettered piece of art by crafting a layout using all the variations of that chapter's style. The chapter compositions themselves have also been inspired by lettering from the late 1800s and early 1900s.

One of my favorite things about lettering is that you don't have to use the fanciest tools to draw in the fanciest styles. In fact, all you really need to practice lettering in this book are five tools: a pencil (regular or mechanical), a large eraser, a smaller pen for details (Sakura Pigma Micron 03 or smaller, or a Sharpie fine-point marker), a pen for thicker lines (Paper Mate Flair Felt Pen in medium point or Sakura Pigma Micron 08 or higher), and a large-tipped black marker, like a regular Sharpie or Crayola black marker, for larger fills. You might already have all these!

If you're like me and get intimidated by a blank page, or you feel the need to keep everything as perfect as possible, I suggest sticking to just a pencil for as long as you feel comfortable. You can always come back to your sketch later to ink it in.

There are some other tools that might make your life a little easier, but these are all optional items. One of my favorite tools is a pencil eraser. It's great for erasing errors on the tiny details, which there will be a lot of throughout this book. Another optional tool is a white gel pen. It's the best when you want to go back and add details over a filled-in letter. A couple of more tools to have on hand include a ruler, tracing paper or scrap paper, and colored pencils or markers for coloring in the compositions at the end of each chapter.

I want to leave you with three more tips before you start your journey into the wonderful world of ornate lettering.

- First and foremost: Go slow. Vintage lettering is packed with detail work and takes patience. The phrase "good things take time" truly applies here!

- Second, if golf is all in the hips, lettering is all in the sketch—get your pencil drawing to a level you're proud of. The pen can wait until you're ready! If you're getting stuck with the pencil sketch, tracing over the example letters is a great way to accustom yourself to drawing the shapes of the letterforms. You'll start to develop the hand-eye coordination you need for lettering.

- Third, don't be afraid to add your own flair to the styles and get experimental!

Lisa Quine

A PENNY SAVED IS A PENNY EARNED

· BENJAMIN FRANKLIN ·

OLD MONEY

BASIC ROMAN TYPE: A STYLE WITH A RICH HISTORY

When you're learning how to hand-letter and drawing inspiration from the late 1800s and early 1900s (a date range I call the sweet spot due to that era's focus on elaborate typefaces), a fantastic place to start is with a basic roman style. You probably already know what roman is because I'm 99 percent sure you've heard of a good ol' typeface called Times New Roman. And remember Google's old logo? That was a roman typeface too. Open up any novel at Barnes & Noble and the text is more than likely going to be in a roman-style font. Roman style is everywhere, including vintage lettering.

In this chapter, we'll go over how to craft each letter of the alphabet from scratch using roman-styled caps (meaning the letters are all uppercase). I'm calling it Old Money as an easy way to remember the historical style—by picturing a dollar bill. The letterforms in this chapter will serve as a nice base for a majority of the styles covered in the chapters to come. We'll also take a look at how to add a drop shadow, as well as a decorative element inside each letter, similar to the styles featured on the face of US paper currency. We'll call that typeface Fancy Old Money.

GETTING STARTED WITH ROMAN LETTERING

Roman type got its name because it was first developed in ancient Rome and grew popular during the Renaissance. It's still widely used today because it's the most legible style for large portions of text. The distinct serifs and modulation on each letter make it easier for readers to skim over the text and read at a quicker pace.

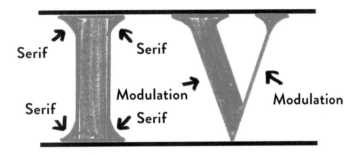

You can identify a roman typeface by its serifs and modulation. A serif is that curved detail on the ends of all the lines that make up a letter. Modulation refers to the change in weight of a letter (the thickness and thinness throughout the letter's structure). As an example, picture Helvetica. It doesn't have those fancy serifs or a whole lot of modulation. The letters have clean cuts on the ends and are a fairly consistent weight throughout. Now picture an American dollar bill. It could be of any denomination—the $1, $5, $100. The typeface on the bill is in roman style.

Now let's stop picturing things and start drawing!

LETTERING IN FOUR STEPS

Grab your pencil and an eraser. At the very beginning of the lettering process, there are four easy steps to follow when you craft any letter in any style:

1. Draw the shape that the letter will contain.
2. Draw the frame of that letter.
3. Add weight or modulation to the frame.
4. Add finishing details.

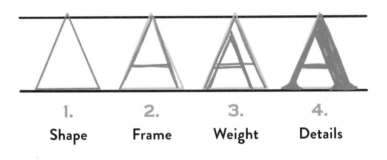

Let's pump the brakes before we jump into the whole alphabet. The most important part of lettering is getting the sketch to the place you want it to be. These four steps will set you up for success!

1. Draw the shape that the letter will contain. This step is perfect for making sure the kerning, or the spaces between the letters, is correct. Without drawing the shapes first, you'd spend a lot of time sketching out the details of the letters and erasing all your hard work where the kerning looked off. This is a more accurate method of predicting the kerning of each letter to save you time. (The shape trick is newer even to me, and it has been a game changer!) There are three basic shapes that I use: rectangle, circle, and triangle. Let's look at the word *drawing*, for example.

Letters like A, V, and W will fit nicely in a triangle, and letters like C, G, O, and Q fit in a circle. The rest fit the standard rectangle shape but at various widths (note the I compared to the N in *drawing*). When drawing out the shapes, it's helpful to keep your pressure on the pencil as light as possible in case you have to do a lot of erasing and moving, if need be.

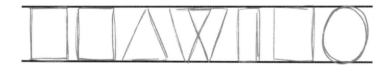

2. Draw the frame of that letter. This should also be done in light pencil markings in case there are multiple edits. Usually, when there are serifs and other decorative details that stick outside the shape, the kerning needs to be adjusted and nudged around a bit. Other than that, this step is a breeze! Just draw the basic frame of each letter in the shape, all one weight and with no details.

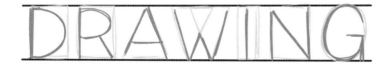

3. Add weight or modulation to the frame. It's helpful to look at the whole alphabet for reference so you can see which parts of the letter stay thin and which are thicker. If you don't have an example of a roman-style typeface in front of you, no worries! All you have to remember is that the downstroke is thicker. This is because when people were using nib-tipped pens to write, more ink would be applied to the paper on the downstrokes and less would be applied on any other stroke direction. It might sound confusing until you see it in action. Let's take a look at some of the most mistaken letters.

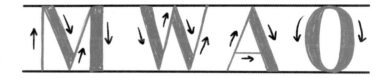

Hand-lettered modulation gets a little tricky because there are really no rules and you can draw letters however you wish. But if you are trying to emulate a roman font, it will look more correct if the modulation is in the right place because it will look more like a historically styled letter. Following is the third step applied to our example word.

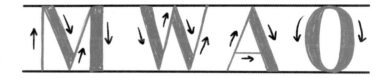

Note: *The weight of each letter has been applied to the downstroke. On the curved letters, the modulation mimics the curve of that letter. It fades in and out toward the top and bottom, like in the left side of the G, for example.*

4. Add finishing details. Because we're kicking things off in a simple roman style, all we need to add are the serifs. It will be easier to draw them with the assistance of a background grid so that you can see how much of a tiny unit the serif contains on the grid. Simply draw out the first serif and try to match the size of it throughout the whole word—but rely on the grid for visual cues.

See? Four easy steps. Grab your favorite pencil (I always use a mechanical pencil) and give it a go! Hand-letter the word *drawing* below the example using the space between the two gray guidelines provided. Remember: shape, frame, weight, and details. If you wish to practice filling in the letters with a pen, do that after sketching it out in pencil. My pen preference is a Paper Mate felt-tip or Sharpie pen.

OLD MONEY

Now is the moment you've been waiting for: drawing out a whole alphabet! Again, this typeface will be the base for a majority of the styles to come. A lot of vintage hand lettering consists of drawing out a shape and filling it in with details. For starters, we're going to nail down the base shape and structure of these roman-styled letters, and we'll do it in the four easy steps we just learned. Grab your favorite pencil and a large eraser and let's start lettering!

Try to draw out the alphabet by sketching each letter in the empty spaces next to the example letter. I've also provided the shape and frame (steps 1 and 2) of each letter for guidance on this first font. Remember to rely on the grid if you get stuck. When you're happy with each letter in pencil, you may go over the letters with a pen of your choosing. I like to use a Paper Mate felt-tip pen. Remember: shape, frame, weight, and details. Enjoy!

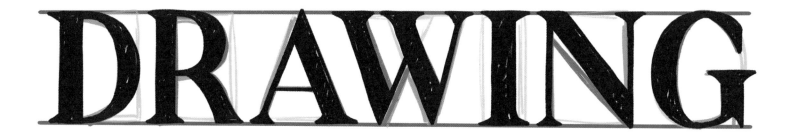

A B C D E F

G H I J K

L M N O P

Q R S T U

V W X Y Z

FANCY OLD MONEY

Once you've got the hang of lettering a basic roman-style alphabet, which we call Old Money, it's time to add a few details to really make your lettering look like a million bucks! If you take a look at the numerals on older versions of US paper money, you'll notice that they have a drop shadow. A drop shadow is the effect that gives your lettering dimension. It's as if there's a fictitious light source shining down on the characters and the characters are casting a shadow. We'll be looking at various styles of drop shadows throughout this book, but for Fancy Old Money, we'll start off with a simpler solid shadow.

For the details we'll be learning next, I drew inspiration from an older $100 bill, specifically the version that was officially in circulation from 1996 to 2013. I used this version because I love the details on the *100* in the top corners on the front of the bill. Fancy Old Money pulls in details from these numbers—the typeface itself is inspired by actual money, like its name suggests.

To hand-letter the alphabet in Fancy Old Money, we're going to start by using our four-step process to hand-letter Old Money. This time around, try to either keep the letters in a lighter shade of pencil—or even use a colored pencil—so that the details inside the letters come through. Also, we're going to add a little more weight and make the letters wider so that we have enough room to draw the details on the insides of the letters. After that, we'll start with the fun detail steps!

Let's take a look at letters A and B.

1. Draw the letter in the Old Money typeface. Instead of filling it in with solid black, use a light gray pencil.

2. For the drop shadow, simply draw out the angles from each end of the letter, all in the same direction.

3. Connect the ends of the angled lines and fill them in with heavier pressure on the pencil so you see a difference in tone between the letter and the drop shadow.

4. Draw a smaller shape within the modulated portion of the letter.

5. Add a drop shadow to the smaller shape so that the top and left side contain the shaded area. It's hard to see the shadow on the A since it's only at the top, but you can really see it on the letter B.

6. Add the lines within each letter. You can use the grid in the practice alphabet at the end of this section (page 19) to help guide you with consistency as to how many lines fill each unit of the grid.

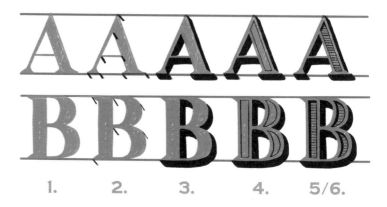

1. 2. 3. 4. 5/6.

Note: *Remember to keep the letter lighter and the details darker so you can see the details pop. You can ink in the details once the sketch is in a good place.*

Your turn to hand-letter Fancy Old Money!

A B C D E F

G H I J K

L M N O P

Q R S T U

V W X Y Z

LETTERING THE COMPOSITION

As I mentioned in the introduction, at the end of each chapter we'll be putting the chapter fonts into action by hand-lettering a full quote. To keep up with the theme, we'll be lettering the saying "A penny saved is a penny earned," coined by our friend on the $100 bill, Benjamin Franklin.

The key to hand-lettering a whole phrase is to pinpoint the levels of hierarchy, or which elements are more important than others within the quote and match the various levels of emphasis visually. It also helps to identify any pattern in the quote and make that visually prominent as well.

In the phrase "A penny saved is a penny earned," there are three levels of hierarchy. *Saved* and *earned* are the two most important words, followed by the two uses of the word *penny* and then finally *a* and *is a*. Also, because the phrase almost repeats itself, the two parts of the quote will be almost identical in visual treatment, establishing a nice flow for the reader. We will also be including the quote's attribution below the quote.

The steps in crafting a composition, a fancy word for the term layout, are fairly similar to how we started each letter. You can follow along each of the composition steps in the practice space provided. Each chapter features two blank pages: one that includes a graph for guidance, and one that's blank so you can practice the layout without the training wheels when you're ready.

1. **Draw out the shapes that will contain the words and make sure that the quote is centered and balanced on the page.** I also lightly sketch out the center line of the composition so that it's easier for the eye to see if the shapes and words are balanced.

2. **Draw out the shapes of each letter.** For this composition, I'm making the words *a* and *is a* much smaller and I'm sandwiching them between two decorative lines because this technique is a common layout style in vintage posters, packaging, and other typographical pieces. These words and the attribution will be in a sans serif (a font without serifs) type style because it's quick to draw and unstylistic on purpose.

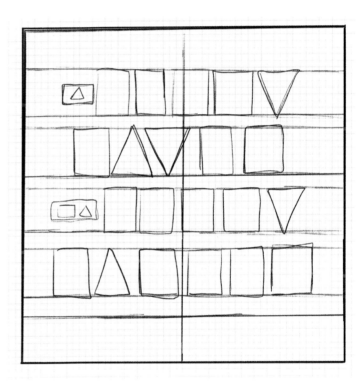

3. **Decide which words get which style.** The two instances of the word *penny* will be lettered in Old Money and the most important words of the piece will be in Fancy Old Money, so that the visual hierarchy matches the quote's points of emphasis.

4. **Add a decorative border also inspired by US paper bills.** With a ruler, simply add a border that's two grid units into the center of the composition so that it is the same width on all sides.

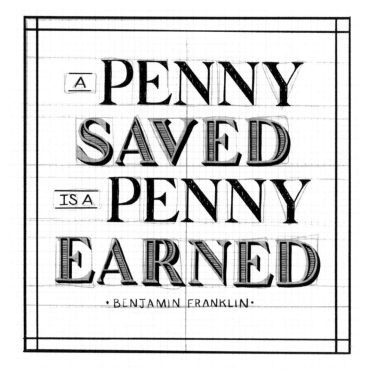

5. **Mimic the same linework that was used inside the letters of Fancy Old Money all around the border.** When you get to the corners, you can really do anything you want—fill them in, add a circle, and so on. I saw that one version of the $100 bill used L-shaped corners, so I copied that element.

Vintage-inspired lettering is usually filled with ornate details, but the downfall is how long it takes to draw them. When you're adding the lines to your border, feel free to put on your favorite music, podcast, or whatever you like to pass the time. Sometimes silence is meditative too!

6. **Once you've completed your lines, add little circles within the border as shown.** This element was also inspired by older versions of dollar bills.

And there you have it! Your first completed, vintage-inspired, hand-lettered composition!

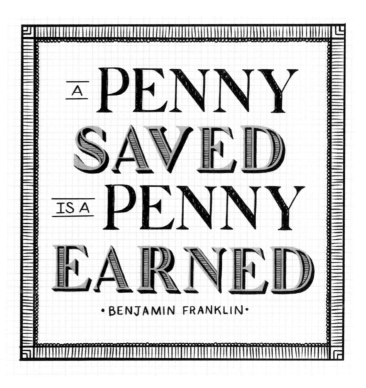

A PENNY SAVED IS A PENNY EARNED

• BENJAMIN FRANKLIN •

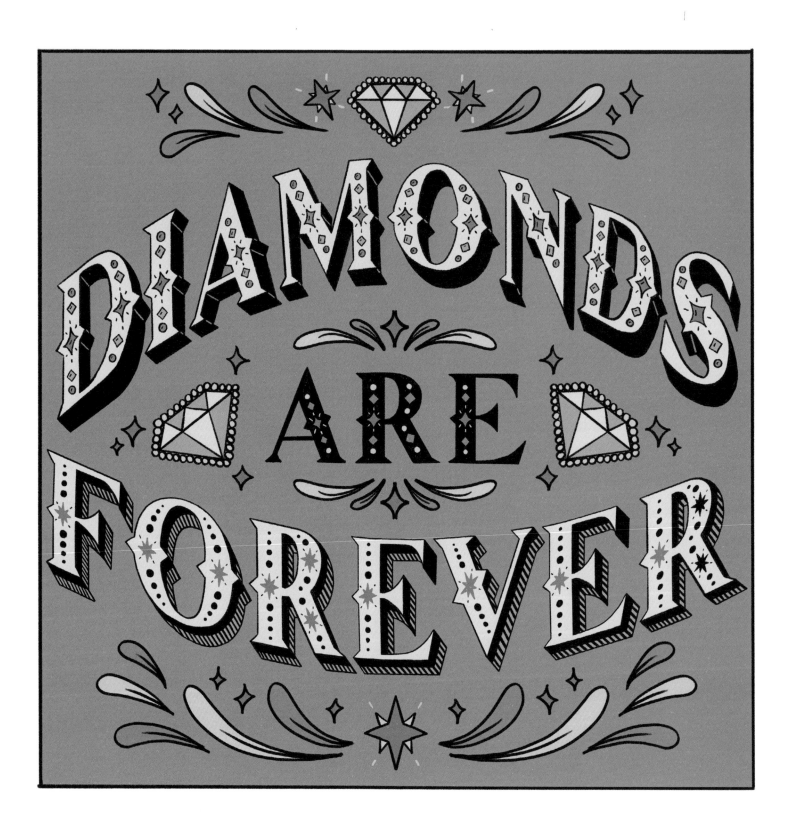

JEWELED EMBELLISHMENTS
SPARKLING SERIFS WITH DAZZLING DETAILS

One of the most fun steps in lettering is adding the details! Details are what set each typeface apart and what help a lettering artist find their unique style. By using simple shapes like triangles, circles, and squares, you can elevate a simple letter and make it shine. If you take a look at some of the advertisements, posters, and book covers from the late 1800s, you'll notice that the letters often have details and embellishments inside them. Because you have already mastered a basic roman font style, we're now going to add a little more pizzazz with vintage-inspired details.

We're going to start with our Old Money typeface (page 13) and increase the modulation, giving us a wider canvas to add our jeweled embellishments. Embellishments are decorative details added to letters to make them more attractive or to fit a specific style. Just like lettering, certain jewelry designs were also unique to the time periods we're looking at, so merging the two is only natural. Although the shapes of the details may be simple, they make the letters appear to be decorated with precious stones and even sparkling stars. We'll look at three possible ways to embellish the letters and how to use all of them when crafting a full quote. Once you practice the three styles provided, I encourage you to test out your own ideas too!

SPARKLING SERIFS

Let's begin with our first font in this chapter, Sparkling Serifs. We are going to use the same four-step process we learned in Chapter 1 (shape, frame, weight, details); but we'll also break down the detail section into more steps as we begin to create embellishments. All of the chapters will use our handy four-step process, but it's the fourth step that gets really interesting!

For this first typeface you have two options:

1. You can use just a pencil and eraser. I recommend getting a retractable eraser (or pencil eraser) that's small in size so that you can easily erase the center of the letter where the details are going.

2. If you want a darker fill—and therefore a higher contrast to make the embellishments really pop—feel free to first use a black pen or marker for the fill of the letter and then a white gel pen for the jeweled embellishments after you've let the ink of the fill dry. If you use a white gel pen too soon it will mix with the black ink and become too gray. I prefer this method because the white gel pen helps me better control how the embellishments are formed.

In Chapter 1, we looked at the step-by-step process for A and B, so we'll continue alphabetically with C and D. Using the steps we went over on pages 15 and 16, execute the letters with shape, frame, weight, and details all in pencil. Instead of filling in the letter, just leave the outline empty.

It helps to draw a cross in the middle of a circle for extra guidelines

Now for the fun part! We're going to add a twinkling star in the middle of the modulated areas and then smaller squares and circles around the stars to deck out the letters. We'll also be adding in a popular hand-lettering element: a spur, which is a triangular decorative element often found protruding from the center of the letter. Spurs are most common in both tattoo and western-themed typefaces. If you were to type in "cowboy-themed" anything on Pinterest, you'd be bound to spot some spurs.

1. Start out by drawing a very light line in the center of the modulation. This will be your guide when finding the center of the five decorative elements.

2. Once you have your guideline, lightly sketch out where you're going to add the five shapes. Start with the four-point star in the middle (it's nice when the center falls on a line on the background grid) and draw a small cross. This cross will give you four reference points as to where the points of the star end. Next, draw a circle right around the cross, and then a larger circle that almost touches the outline of the letter itself. The larger circle is where you'll add the four dashed lines to make it look like the star is twinkling.

3. Draw two circles in descending sizes outward from the cross in the center. You want to make sure the circles where the squares will be match in size and spacing from the center, and the same goes for the smaller circles where actual circles will be. This second set is much like the "shape" step in our general lettering guide—we just want to block off the areas where our next steps will go to make sure everything is where it should be.

4. Once you have five blocked-off areas that match in size and spacing, draw out a four-point star, four dashes in the center of the star's sides, two diamonds, and you already have the last two circles. You can also add the spurs, which highlight the shape of the stars. The points of the spurs should match the horizontal points of the stars.

5. You are ready to fill it in! You might find yourself erasing and redrawing the shapes a bit because you want to make sure the white shapes are large enough. Once you fill in the letter, the shapes themselves tend to shrink because the outline of the shapes fade into the fill of the background. After a few letters, I'm sure you'll see what I mean and get the hang of it!

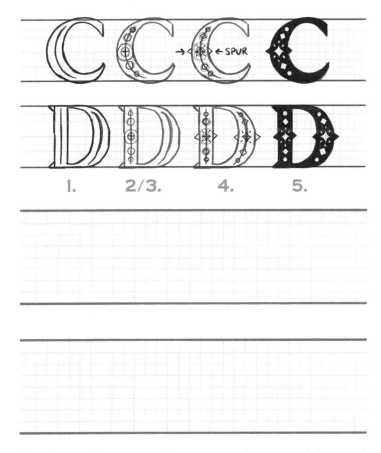

If you're ready, jump to all twenty-six letters and shine on!

A B C D E F

G H I J K

L M N O P

Q R S T U

V W X Y Z

DAZZLING DETAILS 1 AND 2

This chapter's style lends itself to so many fun possibilities because all you have to do is establish a pattern of shapes (e.g., circle, diamond, star, diamond, circle) and draw the pattern consistently in the modulation throughout the alphabet or word.

There can also be a lot of variety in the use of black and white.

1. In Sparkling Serifs, we filled in the letters with black but had white details.

2. In Dazzling Details 1, we'll take a look at the letter and the details only being outlined with just the drop shadow being filled in.

3. In Dazzling Details 2, the letter will again be outlined, but this time the details will be filled in. The drop shadow will get two treatments: half solid fill and half striped.

All this variety, with dainty details and fills and outlines, will make for an even more eccentric, vintage-inspired quote in the end!

Let's start with Dazzling Details 1. This style should be straightforward now because it follows the same shape and pattern as the previous font, Sparkling Serifs. Instead of filling in the letter when you get to the last step of the detailed part, you're going to erase your guidelines and finalize the outline of the letter and details. Once you have a solid outline (whether in pencil or pen), there are just a few more steps:

1. Draw out the letter in the Sparkling Serif typeface using steps 1–4 from page 29.

2. Add a little highlight dash on each of the five shapes. This gives the shapes dimension and creates the illusion that the shapes sparkle. The highlight can be on whatever side of the shape you want, but it's important that the highlight is consistent throughout the letter. In this font, the highlight is on the upper left-hand side. (The highlight addition can also be applied to the Sparkling Serifs font if you wish. The only reason I left it off was because the simple font is usually a smaller word in the quote pieces, and you might not be able to see this tiny detail as well.)

3. Add the drop shadow lines, starting with the letter's corners. You already know how to do this from Fancy Old Money on page 18.

4. Once you've drawn the diagonal lines for the drop shadow, connect the lines and fill them in with a pencil or pen. Leave the lines that you drew out from every corner of the letter in white, or go over these lines with a white gel pen. This technique is a quick additional ornament that gives the letter a new look. Like the highlight on the shapes, it provides the drop shadow with even more dimension.

The last font is Dazzling Details 2, and it's definitely my favorite of the three because it looks astrological and I love the striped drop shadow. This font is very detailed and therefore perfect for the top tier of visual hierarchy in a quote.

Because it's more detailed, there are a few more steps to this one, but the extra effort is totally worth it!

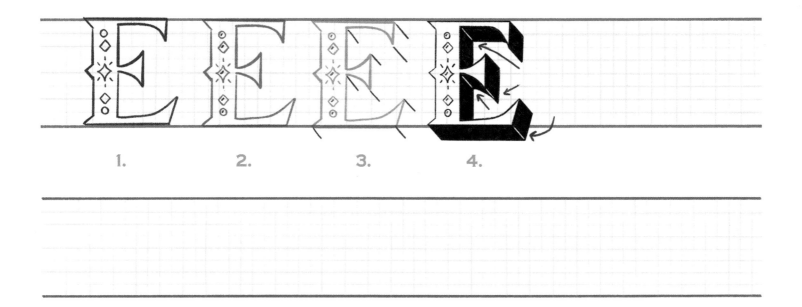

1. 2. 3. 4.

1. Start by drawing the outline of a basic roman letter with wider modulation (just like in Sparkling Serifs).

2. Draw a guideline down the center of each area of modulation.

3. Using the guideline to center each shape, draw an eight-point star with four starburst lines at the center. Add four dots descending in size outward from the center star. Be sure to keep an eye out for even spacing and use the gridded background for help. Lastly, don't forget the spurs!

4. Once the details have been added to the letter, focus on the drop shadow. Start with the angled lines at each corner and crease. Make sure to extend them a little further out since this drop shadow is slightly thicker than the past fonts.

5. Connect the angled drop shadow lines in each corner and, just like we did for the details, draw a line in the middle of the drop shadow space. Because I personally enjoy the striped drop shadow so much, you'll see that I gave the stripes a little more real estate in the example letters provided, but the stripes don't have to be smack-dab in the center.

6. Give the drop shadow a solid fill in the spaces closest to the letters, and in the remaining space, add consistent stripes. If you run into spacing issues on one side, it's okay to make the corners and ends a little thicker. Now you try below!

Dazzling Details 2 is an extra fun font because of that striped drop shadow, but it requires some extra time. This font style is a great chance to practice a bit of patience and see your work pay off in the end!

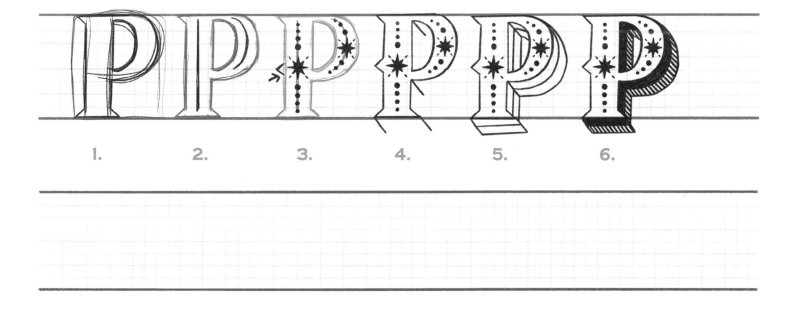

1. 2. 3. 4. 5. 6.

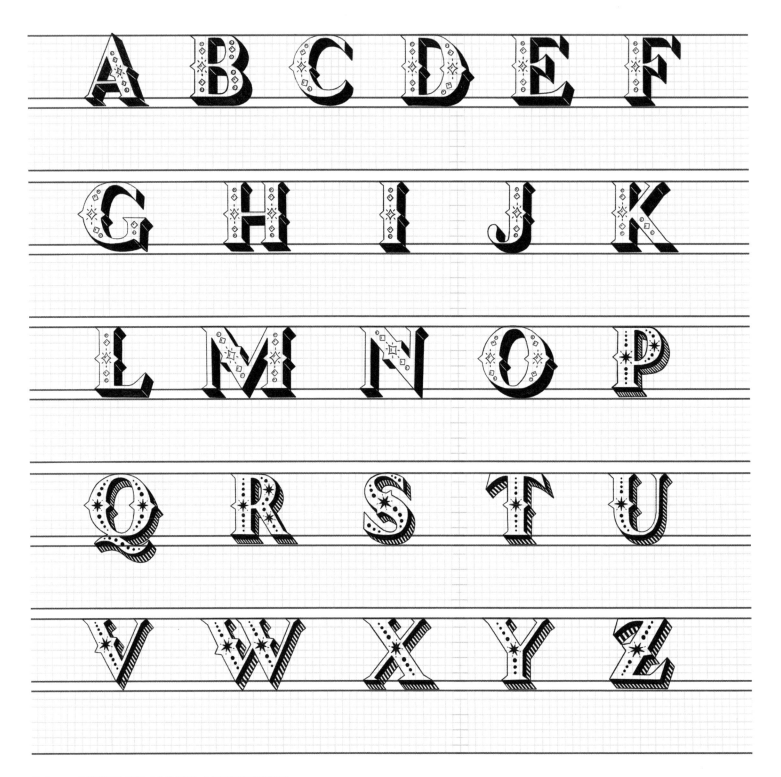

LETTERING THE COMPOSITION

Time to put all three fonts to work in a dazzling hand-lettered quote! We'll even add some illustrations to bring it to life. Because this chapter focuses on jewel-like embellishments, "Diamonds are forever" was the first thing that popped into my head (and the James Bond theme song hasn't left for weeks).

For this composition, *diamonds* and *forever* are the two crucial words. Both can be treated the same way and still make sense in the visual hierarchy, but the word *forever* holds just a tad more weight, which is why we're going to give that one the Dazzling Details 2 treatment. *Diamonds* will still shine in Dazzling Details 1 font, leaving *are* to be lettered in Sparkling Serifs.

1. **Draw in the guidelines for the words.** In a majority of the general vintage typography references I've collected from the late 1800s and early 1900s, the compositions are full of curves and arches. This is because it gives the layout movement and captures the attention of the viewer in an elegant way (rather than the quick and aggressive straightforwardness of a modern campaign sign, for example). We're going to use a symmetrical curved grid in this project.

2. **Even though we're going to give them different font treatments, the words *diamonds* and *forever* can still be similar sizes.** Start by sketching out a lemon shape that takes up a majority of the page, but leave some space at the top and bottom for decorative elements (see the first image for reference). I find that drawing the outline of the shape that will contain all the words is very helpful. Once you have two curved lines that take up a majority of the space where the quote will go, slowly add the rest of the guidelines.

3. *Diamonds* and *forever* will have four guidelines: the top of the letters, the bottom of the letters, the center line (for the stars and spurs), and the bottommost line is where the drop shadow will come to. The word *are* is fairly easy—it should be smaller and right in the middle.

4. Symmetrical curves can be sort of tricky. I've used compasses before, but for wider arches like these, try tracing the edge of a large bowl. That way the curves will match for sure!

5. Group the next set of guidelines together. The shapes of each letter come next. Make sure you leave some extra room to account for the larger drop shadows. You'll need only the first three out of four guidelines for the arched words right now. Next, we're going to add some guides for the decorative illustrations. I usually block off the areas I want to add embellishments to, like where the triangles on the sides of the word are. I then use the shape method to block out details themselves. The larger circles are going to be diamonds, the smaller circles will be four-point stars, and the curved lines will be splash-like flourishes. The grid is key here to help keep everything as symmetrical as possible.

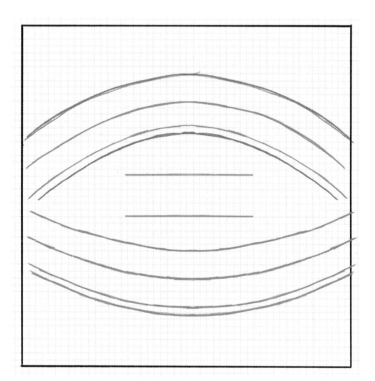

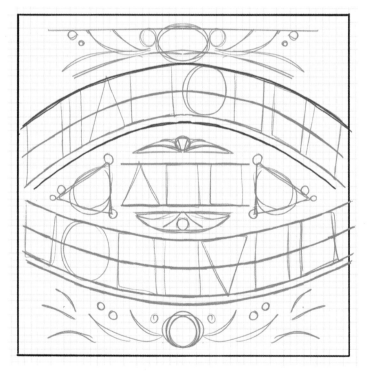

6. Focus on getting the sketch to a place you enjoy and are happy with. The closer the sketch is to that place, the easier filling in the details will be, especially once you start using a pen. For this step, fill in the letters using the steps you've practiced in this chapter.

7. Sketch out all the remaining details. If you don't want to rely on just the grid to help keep the details symmetrical on both sides, tracing paper is another tool you can use. For this method, draw one side of the composition, trace over that side with the tracing paper, then flip over the tracing paper and trace the reverse layout onto the composition. The pressure of the pencil will help leave a mark on the flip side facing the composition.

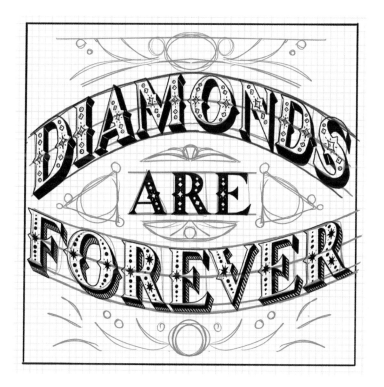

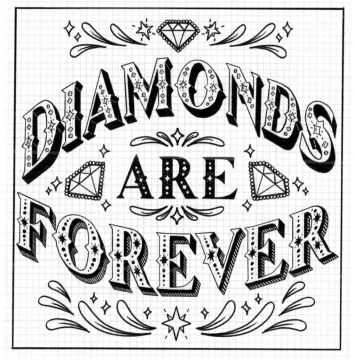

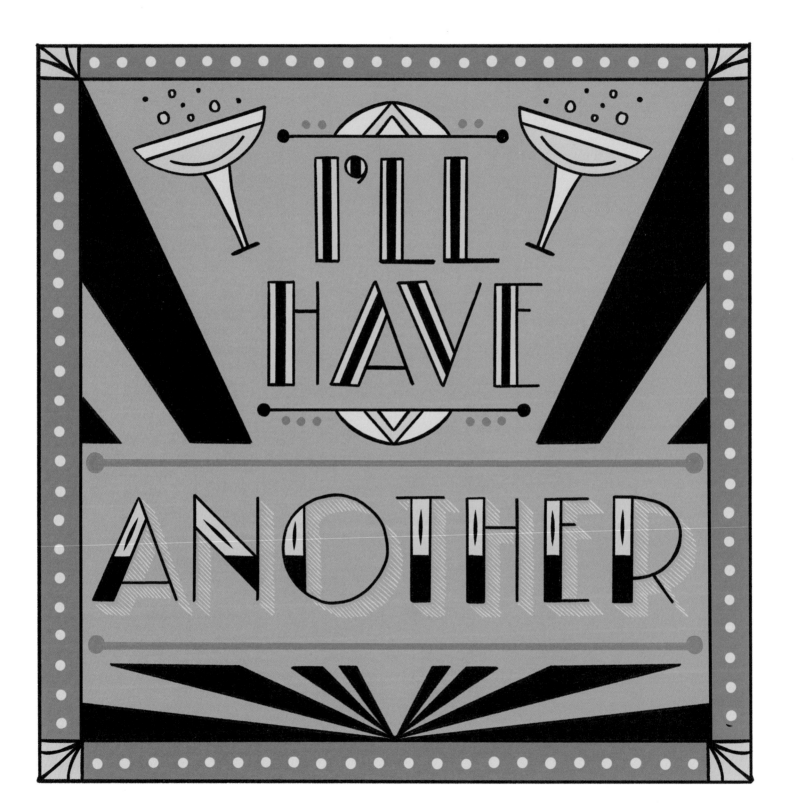

HANGING AROUND THE JUICE JOINT

A COCKTAIL OF ART DECO-INSPIRED STYLES

As you'll notice, my favorite time period to pull inspiration from for typography and decorative elements is the late 1800s and early 1900s. One of the most definitive styles from this range is art deco. Art deco typography is highly recognizable for its high contrast in line weight and sharp, geometric letterforms. This style was commonly used for branding high-class businesses and showcasing expensive items.

Another common use for art deco typography was for branding bars and speakeasies. During the Roaring Twenties, Prohibition was still in force and there were a lot of illegal and homemade alcohol operations. Gin was a cheap beverage to make, but it had a harsh taste; thus, the cocktail was born. Chapter 3 is all about exploring art deco letterforms and crafting your own cocktail of styles.

GIN RICKEY

If you're a fan of *The Great Gatsby*, you might know that a Gin Rickey is a simple cocktail containing gin, lime juice, and seltzer. You'll also notice that art deco typography is made up of simple and sleek sans serif typefaces—simplicity is the theme we'll be pursuing in this typeface. To begin, you're going to want to use a thicker pen, like a felt-tip or heavier Micron pen, because you want to have the same line weight throughout each letter. This is the first typeface that doesn't have a gradual increase or decrease in modulation, but instead it features harsh contrast—making it easier to hand-letter.

Because this style is so simple, we'll test out a couple of variations within each typeface. For Gin Rickey, we'll look at letters with a solid fill and also with just an outline, leaving the modulation open. If you wish, after you sketch a letter, you can outline the letter in pen and then fill it in with your pencil. You're the bartender here!

For Gin Rickey, grab a pencil and let's test out a couple of letters.

1. Draw the shape of the letter.

2. Add the frame.

3. Add the weight to the left side of the letter. When you add the outline of the weight, draw a straight line on the right side of your frame. Take a look at the *F* and *Q*, for example. The straight line is on the right side of the left-most frame. You can also lightly fill in the weight if it helps you clearly see the letterform.

4. Finally, you can either fill in the weight or leave the letter as an outline for a different, lighter style.

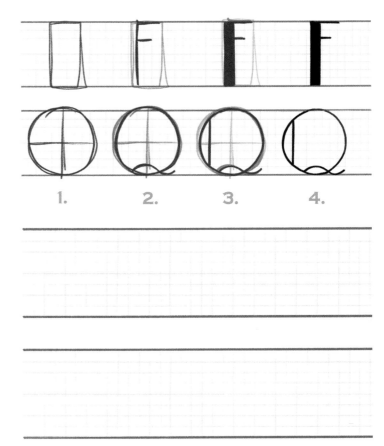

1. 2. 3. 4.

Time to practice the whole alphabet! Remember, add the weight to the left side of the letter by drawing a line on the inside of the letter. There are special occasions—like the M, N, and W—that get the weight applied to the downstroke. Take a look at the example letters—they will help guide you.

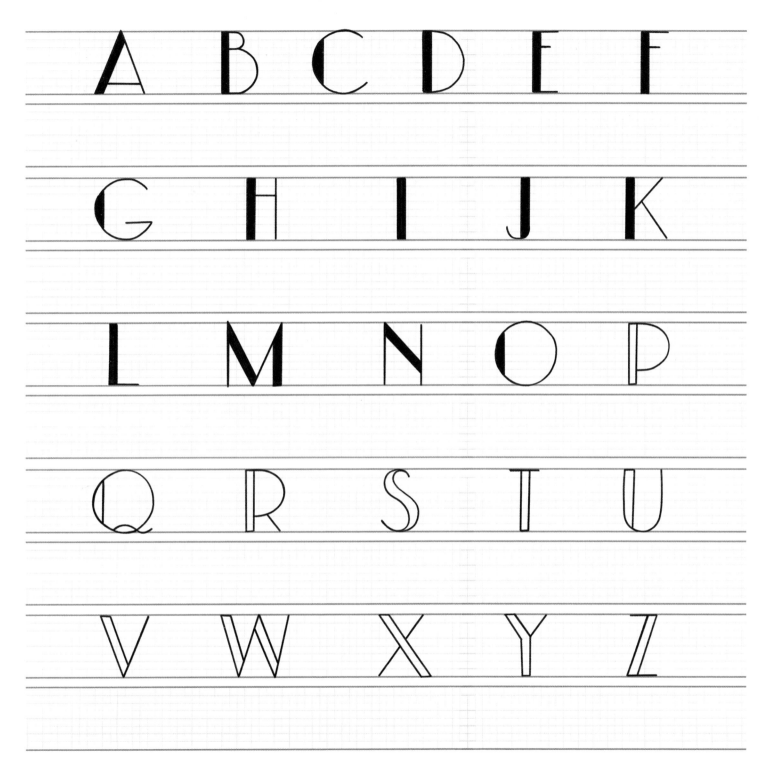

BEE'S KNEES

The Bee's Knees cocktail is a bit more complicated because it includes more ingredients, just like our next font! There are four different variations in the alphabet practice spaces on page 46, so you can see how creative this font can be with just a few lines! Geometric linework and patterns are more styles that are specific to the art deco movement and can be easily added to the thicker modulation in the art deco typefaces.

As I mentioned earlier, Bee's Knees includes four variations of lettering, which you can see in the example alphabet on page 46. The first two styles in Bee's Knees include different placements of a thick black line. In the first few letters (A through I), you'll be able to practice adding a black line to the right side of the modulation. In the following group of letters (J through O), the black line will be added to the center of the modulation, leaving tasteful negative spaces on both sides. The key in both styles is to have consistency in weight, so use the grid to make sure each letter in the series matches.

Because the first variation is pretty straightforward, let's take a look at the second variation with the black line in the center.

1. Draw the frame of the letter.

2. Then add a thicker weight to the right of the frame (I used two grid squares for this one).

3. Sketch a line down the center of the modulation and lightly outline where the black center line will go to. Make sure there's an even amount of space on both sides. This is the second variation of the Bee's Knees style.

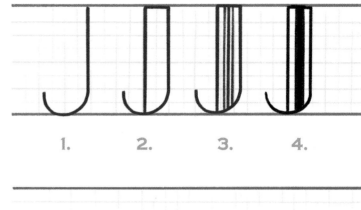

4. Fill in the black center line.

The third style in Bee's Knees is just to add two white lines in the modulated area (letters P through U on page 46). It's easy to do if you have a white gel pen, but if you don't, be sure to sketch out two rectangles, which will remain unfilled, before filling in the black area.

Of course, I saved the best for last. The fourth and final Bee's Knees style is a bit more detailed and will require either a lighter and darker pencil or a pencil-and-pen combo (similar to Fancy Old Money on page 18).

1. Draw the shape, frame, and weight—the same steps that we used for Gin Rickey. Leave the letter in outline form.

2. Cut the modulation in half, filling in the bottom with a darker color and the top with a lighter color.

3. Add a decorative sliver in the top portion using the darker shade. This sliver should be slightly curved and come to two points before touching the edges. If you'd like, you can create a straight line that's the same width throughout and have it go to the edges. This step is totally up to your personal preference (as is all hand lettering)!

4. Focus on the drop shadow. This shadow gives the illusion of a fill by using hatching, which is a series of lines all going in the same direction. It will be easier if you outline where the hatching will go by lightly drawing the shape of the drop shadow first.

5. Create the hatched lines, making sure that they all match the angle of the drop shadow. You should try to keep the spacing close to consistent, but remember that it's the tiny inconsistencies that make the font look hand-lettered and still visually appealing. When you're done with the hatched lines, lightly erase the shape of the drop shadow and redraw any of the hatching you erased in the process.

There are a lot of fun variations within the Bee's Knees typeface. If you have any fun styles of your own, feel free to test them out. I would recommend first lettering a couple of letters based on the examples provided, just so you get the hang of drawing the different details. Cheers!

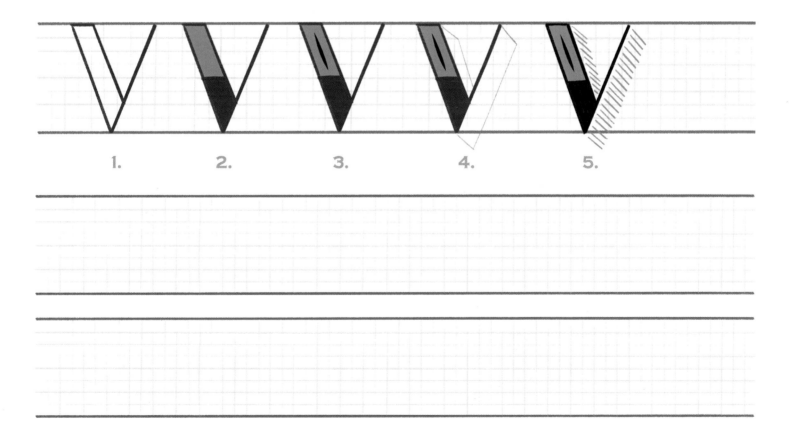

1. 2. 3. 4. 5.

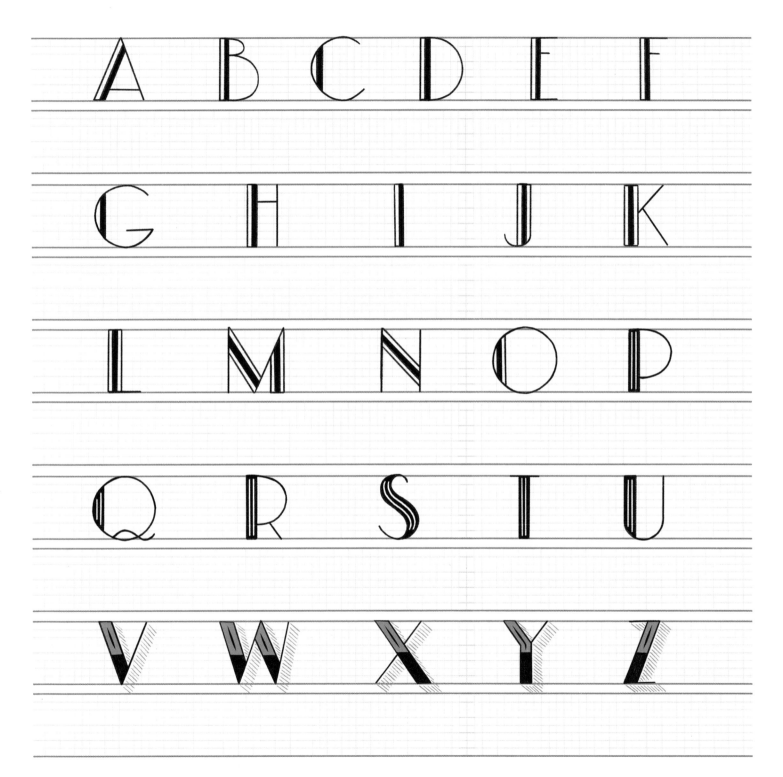

LETTERING THE COMPOSITION

The quote for this chapter includes the three most common words when cocktails are involved: "I'll have another!" (A phrase also perfect for chocolates or cups of coffee.) We're going to focus on my two favorite variations from the Bee's Knees typeface and make this quote dynamic with the boldness of angled burst lines around the words.

1. **Block out where the words are going.** *Another* is the word with the most prominence, and to give it the art deco treatment, we're also going to add two decorative lines, one above and one below the word. Because these two lines will affect the placement of the words *I'll have*, we're going to include the two lines in the step. The top and bottom lines for *another* should be larger than the lines for *I'll have* to add even more visual hierarchy.

2. **Add the shapes of each letter and adjust the guidelines if needed.** Be sure to include punctuation in this step; then your letter spacing will be that much more accurate. Draw an oval where the apostrophe in *I'll* should be.

3. **In the remaining space, fill the canvas with art deco–inspired decor.** Start by sketching out a border all around the canvas. Then start in the center of the bottom border and draw two lines that go up to the top two corners inside the canvas. From there, draw more lines going down, making sure all lines lead to the same spot in the bottom center for a starburst effect. Add the outlines of two fizzing gin cocktails to fill the space on both sides of the word *I'll*. Lastly, draw a line of triangles that descend in size from the center on the top and bottom of *I'll have*. Now the canvas should be filled in nicely with art deco elements.

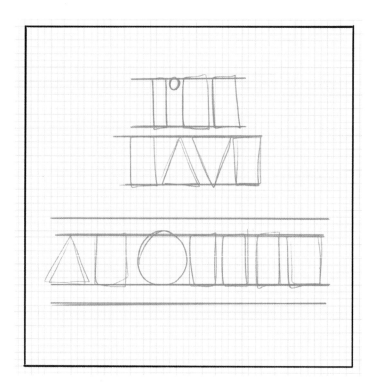

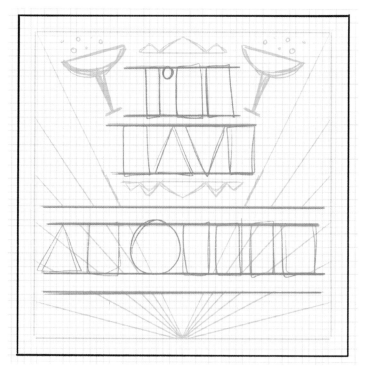

4. Once you have the sketch all sorted out, use the steps we learned in this chapter to hand-letter the whole phrase in the art deco fonts. We're going to use the second and fourth variations in Bee's Knees. The word *another* is in the fourth font, because it's at the top of the visual hierarchy and therefore it's slightly bolder and more detailed. *I'll have* is also detailed and in the second font style of Bee's Knees, but it's slightly simpler.

5. To finish off the chapter quote, start on the outside and work your way inward. First, outline the border with a ruler or straightedge, then add decorative corners and dots. The dots in the border are a nice accent to the dots that are fizzing out of the cocktail! Next, fill in the starburst line, alternating between shaded and empty space. Keep working inside by darkening the lines and art deco elements that run horizontally between the words. Finally, complete the piece by finishing the gin cocktails.

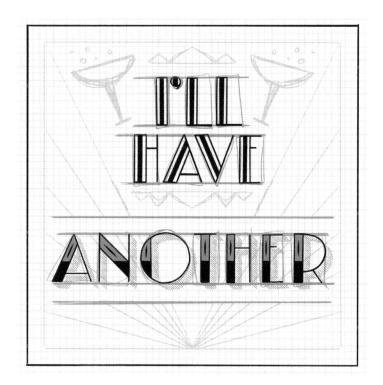

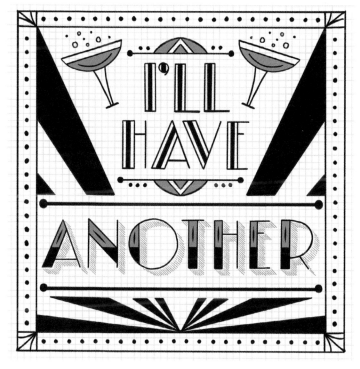

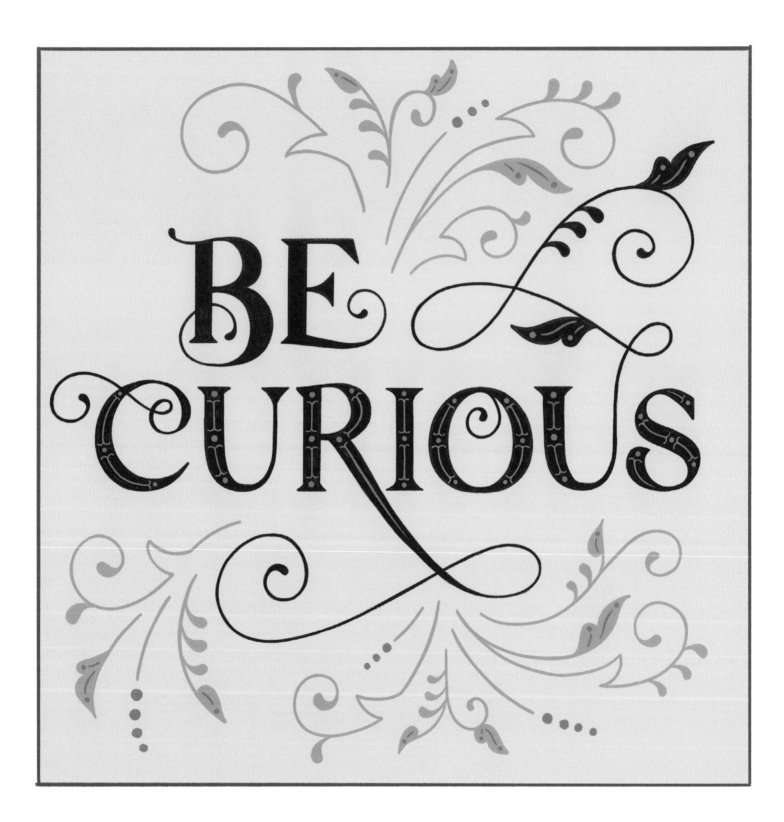

SWIRLING EXPERIMENTS
CLASSY CUSTOMIZED LETTERING WITH SWASHES

This chapter might be the most challenging in the book. Adding those swirly elements to letters gives your lettering a very elevated and customized look. That look is what distinguishes a word that could have easily been typed out and traced from one that was crafted to fit a specific layout. While swashes themselves are not specific to any era in particular, you'll find them throughout work from the late 1800s and early 1900s because so much typography was drawn by hand and swashes gave pieces a classy, one-of-a-kind look.

Swashes are crucial to the look of vintage lettering and can be applied to any of the typefaces in this book. A swash is a curved flourish that is added to a letter to replace a serif. For this chapter specifically, we'll work on a handful of popular swashes for each letter, how to add details to a letter with a swash and how to integrate swashes into a hand-lettered quote and keep the layout balanced.

FLOW MOJO

In the first font we're going to letter, we'll revisit our old pal, the basic roman serif (page 14). We'll take a look at how to replace some of the serifs on each letter with a nicely flowing swash. You might want to stick with a pencil for this one and take out an extra sheet of paper to practice getting the curve of the swashes just right—or try experimenting with your own swashes!

Instead of starting with the end result of a roman serif letter, we're going to start with the frame.

1. Sketch out the frame of the letter.

2. Lightly draw out some possible locations for a swash. The more swashes, the gaudier the look of the letter, so to keep things simple, we'll look at just one swash per letter. (Well, two for the H, because I couldn't resist!)

3. Stick with the bottom swash of the G—it's the grandest of the three options! The next step would be to add the weight and modulation of the letter. Similar to when you add weight to letters like C, O, and Q, you want to make sure the modulation gradually decreases into the swash.

4. Add your details. After adding the serifs, let's put a teardrop at the end of the swash. Check out the quick three-step process for that below. You can also end the swash with a circle or even just keep it as a line with no details on the end.

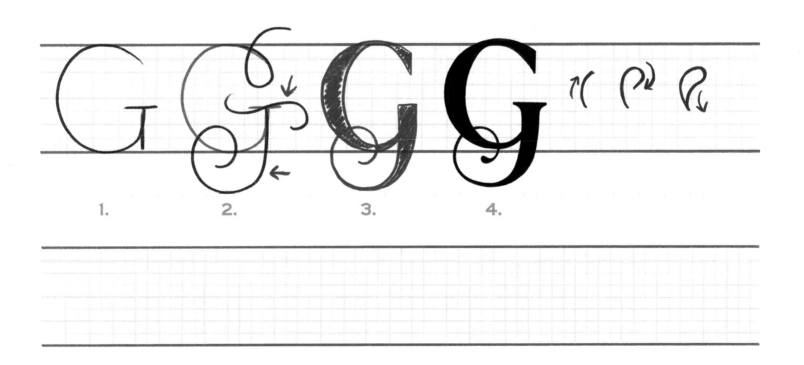

1. 2. 3. 4.

Before jumping ahead to the whole alphabet, I wanted to make sure you had some space to practice the swashes I used throughout all twenty-six letters. You can even try swapping out one of the swashes I used for your own! Also, try taking your time with these letters to get a nice, even curve. It took me years to ensure my swashes weren't wobbly—practice makes perfect. Go find your flow mojo!

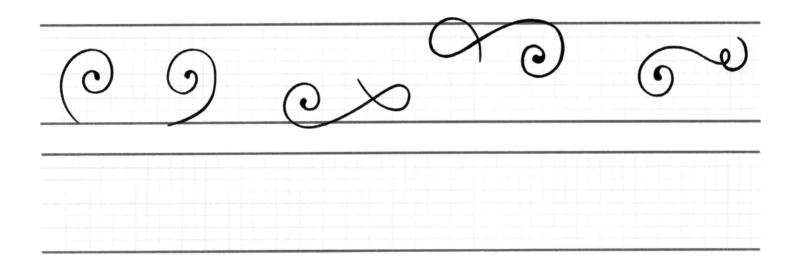

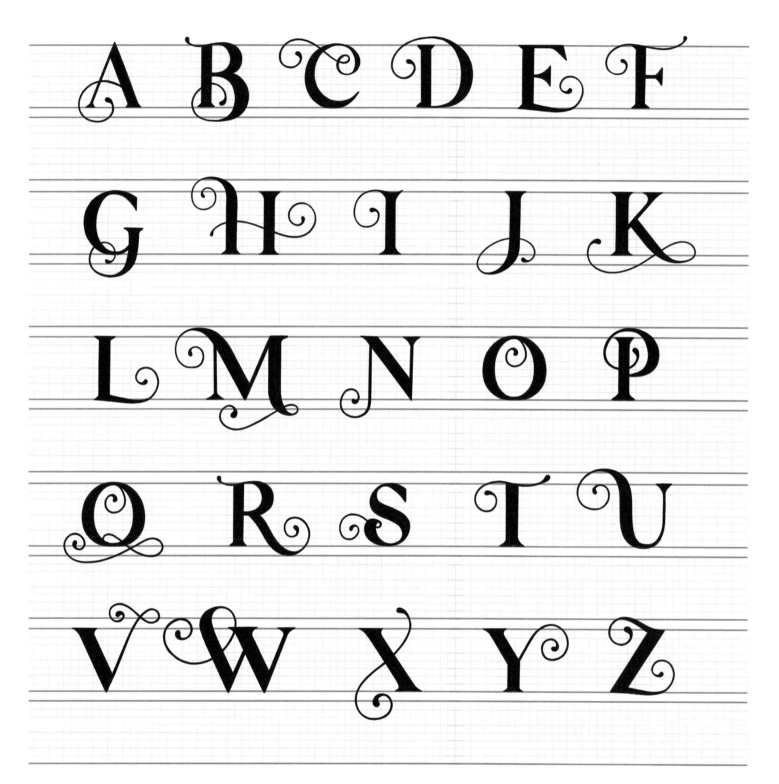

FLAMENCO FLOURISHES

Feel like you're starting to get the hang of swashes? Great! If not, remember that practice is key, especially with this technique. Even though they are a little more challenging, swashes are still fun to experiment with, and they're even more satisfying when you find a combo you love! These flourishes give the letters an energetic feel while still maintaining great elegance. To differentiate between a swash and a flourish, note that swash is a typographical term that refers to the end of a letter that is extended in a curved flourish, and a flourish itself is just a decorative curl in general.

Because these extravagant flourishes transform the shape of the letter, one of the tricky parts of the lettering is adding details and making the effect look consistent throughout

the word or composition. We're going to take a complex in-line detail and add it throughout the alphabet to make sure it fits with the swash.

1. Draw the frame and include a swash. Add the weight of the modulation, but don't fill it in just yet. Simply outline the modulation of the letter and draw a light center line down the middle of the modulation.

2. Next, each full length of modulation will get a decorative in-line graphic down the center. I start by drawing out three circles, one at the top, one in the center, and one at the bottom. I then outline the lines that almost connect the dots. Then, I add a tiny graphic at the ends of the lines, accentuating the dots.

3. Finally, fill in the design!

Time to really let your pencil dance! Give these swashes a go by practicing on the whole alphabet.

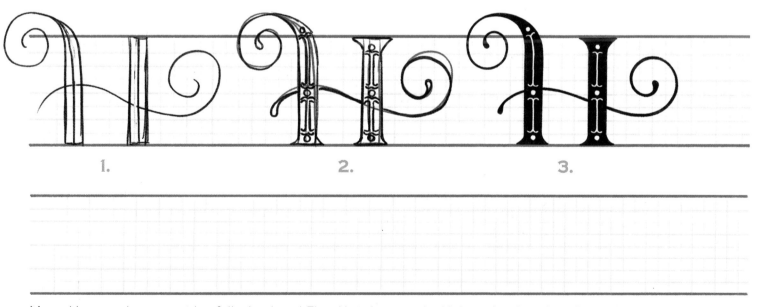

1. 2. 3.

Note: *You can also start with a fully developed Flow Mojo letter and add these details with a white gel pen.*

A B C D E F

G H I J K

L M N O P

Q R S T U

V W X Y Z

LETTERING THE COMPOSITION

I want to start off by sharing that this composition took the longest to sketch. Flourishes are no joke. But it won't take you that long because you have steps you can follow! We're going to combine Flow Mojo and Flamenco Flourishes in this short call-to-action, "Be curious." It's very fitting because finding the right swashes to use is all about being curious—testing them out by sketching flourishes on the ends of letters and seeing for yourself if the result is too busy or a perfectly balanced composition.

Large swashes are great for filling up a canvas when the phrase is not an ideal size. "Be curious" takes up only about a third of the canvas horizontally, so we'll add swashes and flourishes to help fill the negative space.

1. **Block out where the words are going to be.** The space for the word *be* is a little more toward the left because it will be nicely framed by the swash of the second U in *curious*. You can also add the framework of where the embellishments will go to fill the negative space.

2. **Add the shape of each letter and the frame.** The letters that will have swashes will be: B, E, C, R, O, and U. While I experimented with this quote's design, I tried putting flourishes on other letters, but they made the composition too busy. The swashes on B, E, C, and O are smaller and more contained, so they aren't running into other letters in the composition.

3. **The letter R is a great letter to add a swash to because the leg of the R provides a runway for the flourish to really take off!** We're going to exaggerate the swash so that it fills the negative space under the word *curious*. To balance out the composition, there needs to be a similar exaggeration, and luckily the second U provides the perfect opportunity for that. Finally, there's still some negative space left, so we can accent the style of our swashes with vintage-inspired swirls and decorations. You can simply add lines for now, just as long as the movement of the decorations comes across in the sketch, like the following example.

4. **Once you're happy with how the sketch is balanced and fills the page, add the lettering.** *Be* will be in Flow Mojo and *curious* will be in Flamenco Flourishes. If you want to wait and add the in-line details of *curious* when you add the details of the ornaments around the words, that's fine too!

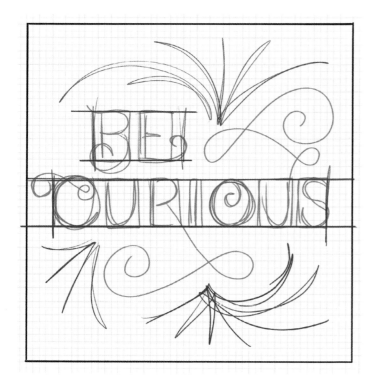

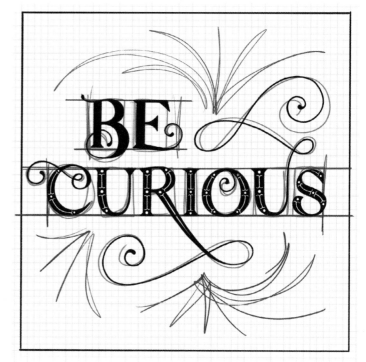

5. After you're all set with the lettering, switch gears to the ornaments. I collected some images of old type-heavy posters and found some swirly lines with nice diversity—we'll use those elements for inspiration here. In the following image, you'll find sketches of swirls, teardrop shapes, dots, and leaflike ornaments to fit in with the style of our swashes and in-line details. Using the sketch lines as guides for the direction, start drawing directional lines with dainty details.

6. Darken the decorative linework and lighten and erase the sketch lines. In the leaflike decorations, feel free to add white dots and lines to mimic the style of the in-line details in *curious*. It always helps to have consistency throughout your piece!

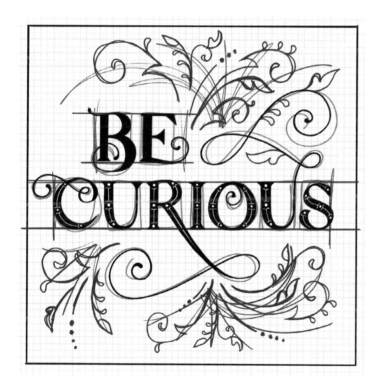

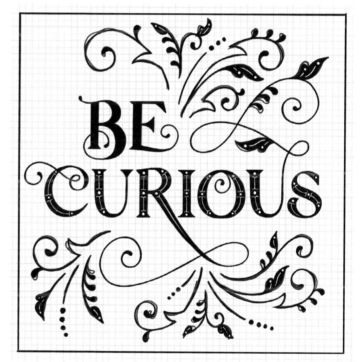

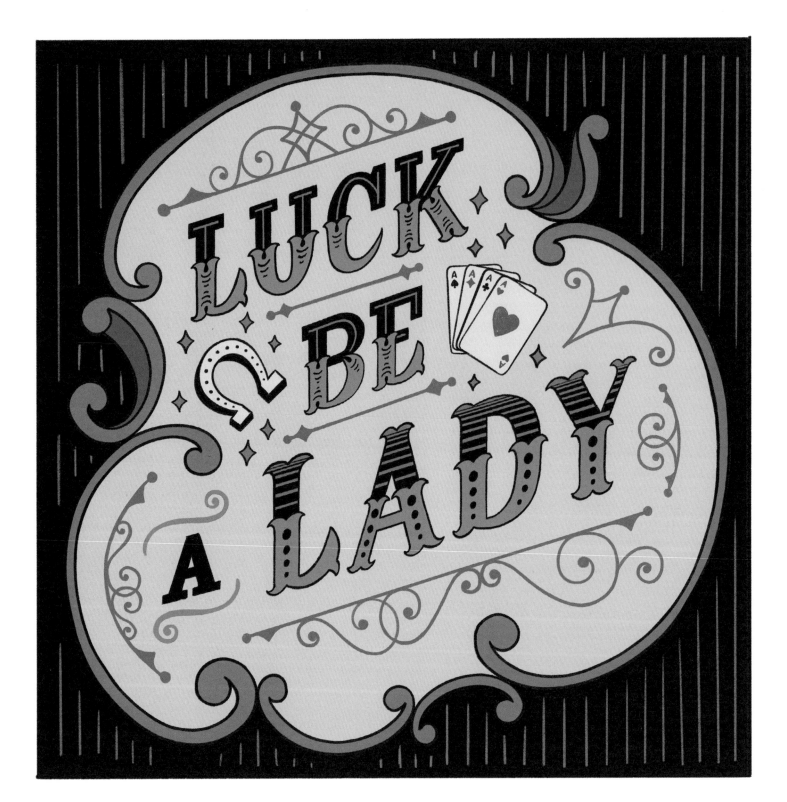

SPLITTING THE DECK

GOING 50-50 WITH LETTER FILLS

Another staple among the many vintage styles of lettering is the "halfsies look" (not the official term), where half of the letter has a set of ornaments inside of it and the other half is filled with either the inverse of that first set or a completely new set of ornaments. This style can be used for many things, but the two instances that come to my mind are promotional pieces, dating back to the late 1800s, for casinos and circuses.

There's a lot of visual contrast in the vintage gambling and casino eras—the black and white of the cards, the bright colors of the chips, the red and black of the card suits, the pinstripe suits gangsters used to wear in the '20s and '30s. So it's only natural that the typography would include contrast as well. We'll take a look at three half-and-half styles, each with their own vintage-inspired contrasting details, and merge them together in a quote inspired by *Guys and Dolls*, the musical from the '50s about underground gambling in New York City in the '20s and '30s.

KING OF DIAMONDS

We're going to kick things off with a font whose ornaments are inspired by the diamond suit in a deck of cards. The diamond shape sits on top of the middle of the letter with a dot to top it off. Much like the face of a card, the same design is mirrored on the reverse side of the center of the letter, flipped upside down and in opposite colors.

We're also going to draw a new type of serif: the slab serif. Slabs are a lot blockier than a classic serif, relying on basic rectangular shapes rather than traditional curves. They were often used in Wanted posters and newspapers back in the day because this style was easy to use in letter-press printing.

1. Draw the frame of the letter.

2. Add the weight, and include the slab serifs in this step. Slab serifs are a little thinner than the width of the letter in this case. The width of the letter is two squares of the grid while the slab serifs are only as tall as one square. (In some western-themed fonts, the slab is even taller than the width of the letter.)

3. Once you have the outline of the letter, slabs included, draw a horizontal line in the center of the letter and draw two diamonds around it. Next, add two circles on the opposite ends of the two diamonds. Lastly, outline the black fill in the top half of the letter, leaving an even white border within the outline of the letter itself. Remember, the outline of the top diamond and circle is going to fade into the background once we fill it in, so we can draw these two objects just a tad larger.

4. Fill in the top half of the letter and the bottom diamond and circle. There you have it—a fifty-fifty split letter!

5. Using a pen, complete the practice letter by filling in the remaining details.

Time to deal yourself in! Go ahead and hand-letter the rest of the King of Diamonds in the space provided.

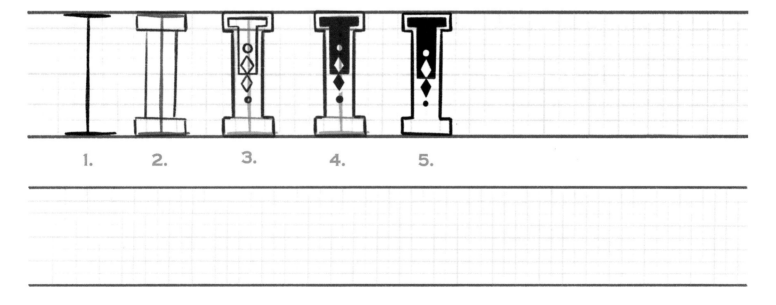

1.　2.　3.　4.　5.

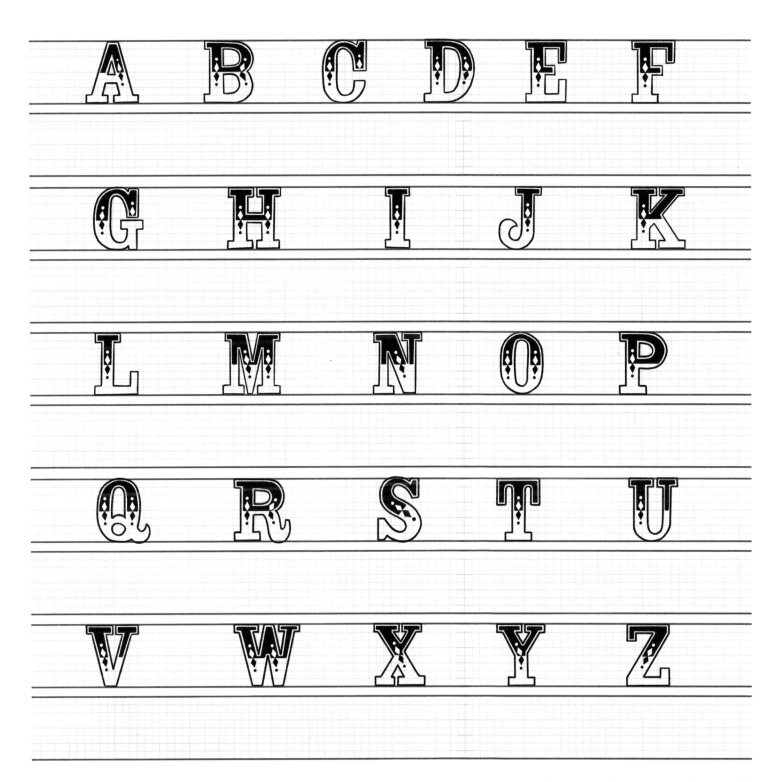

JACKPOT 1 AND 2

Once you split a letter in half, it's fun to brainstorm and sketch two different styles that can fit in one letter. Doing so makes the lettering look twice as ornate! There are a number of different details we could add on both sides, but I've pulled two combos that have popped up in a lot of my vintage references from the turn of the century.

Jackpot 1 is a combo of two highly contrasting sides. The top is a filled-in slab serif with a simple white in-line. The bottom half is a more decorative bifurcated serif that features a teardrop shape surrounded by descending curved lines. And yes, another new serif! A bifurcated serif is one that splits in two and curves outward.

1. Draw the frame of the letter.

2. Add the weight. Once the weight is added, make sure the frame is in the center of the weight, or adjust it so that it is centered. We'll be using this as a guideline.

3. Outline the top and bottom portions, including the different serifs. Again, the top gets a slab serif treatment and the bottom a bifurcated serif. You'll also notice that there's a bifurcated serif in the middle where the two styles meet. In a way, our four-step process (page 14) has shifted order a little. Instead of shape, frame, weight, and details, you can remember these more complex styles as frame, weight, shape, and then details. We will still start with the shape step when lettering our compositions.

4. For the top portion, block out the in-line and be sure to create a small in-line for the slab serifs on top too. Then fill it in with either a pencil or pen. Lastly, create a filled-in teardrop in the center of the bifurcated serifs (a very tiny but common detail in vintage lettering) and draw descending curved lines toward the center. For extra guidance, it might help to lightly draw a triangle in which the curved lines should fit, so you know where to start and stop.

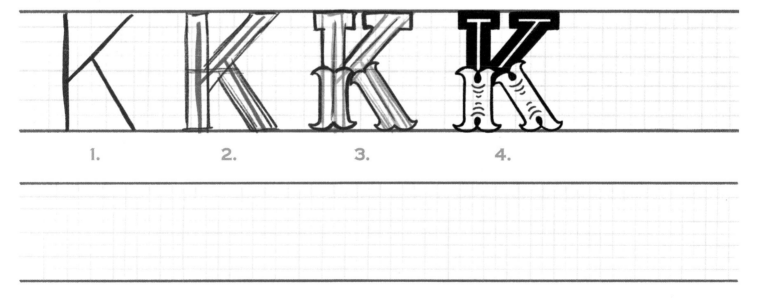

1.　　　2.　　　3.　　　4.

Jackpot 2 is similar to Jackpot 1 in the sense that there are two halves with very different details in each portion, but there are no slab serifs in Jackpot 2. Each half of the letter gets bifurcated serifs on the ends. You'll also notice that one half has stripes where the thickness is descending from the center and the other has dots descending as well. Similar to the King of Diamonds font, the two sides mirror each other, but this time with different shapes.

1. Draw the frame of the letter.

2. Add the weight. Make sure that there's a lightly drawn line in the center of the bottom half for guidance regarding where to eventually draw the circles. (The top won't rely on a center line.)

3. Add the outline of the letter with the serifs included, similar to Jackpot 1, but with the top portion getting the bifurcated serifs as well.

4. As always, the fun part is saved for last! I start with the bottom half of the letter and add the descending circles. Four circles seem to fit most shapes, but there might be instances (like the letter *R*) where only three circles fit. Next, draw in the stripes in the top half of the letter *R* going from thick to thin from the center of the letter to the top. (I highly recommend using the background grid to keep the stripes consistent. That way you don't have to use the world's tiniest ruler to try to keep your lines straight and consistent.)

Now let's split these letters and serifs fifty-fifty with ornate vintage details!

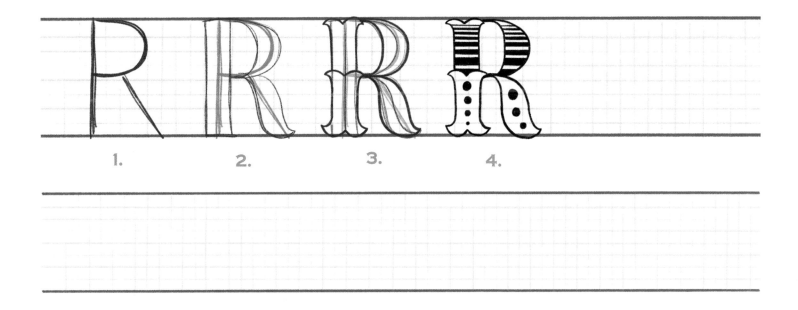

1. 2. 3. 4.

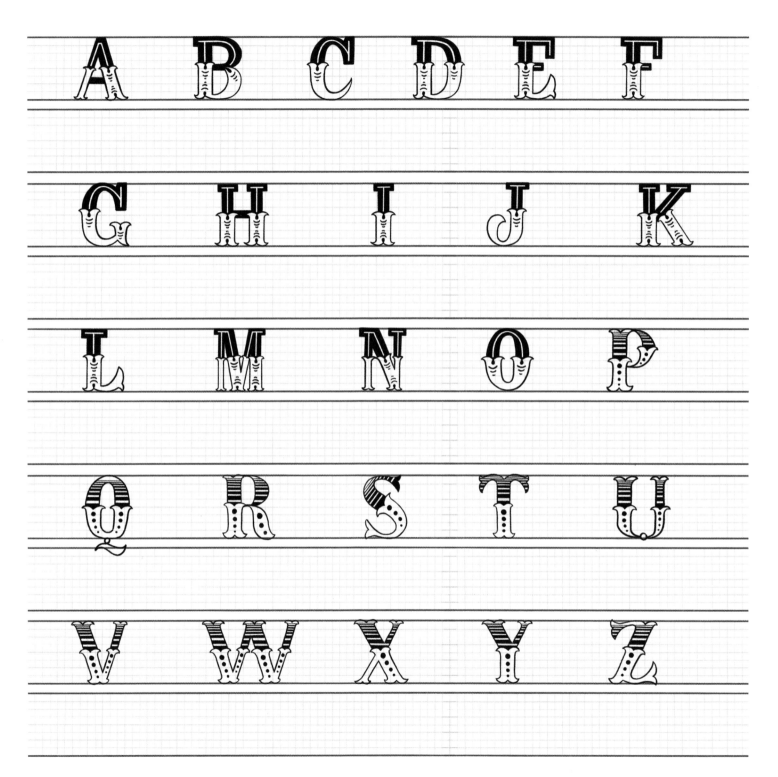

LETTERING THE COMPOSITION

As I mentioned earlier, the chapter quote was inspired by the Broadway musical *Guys and Dolls*, which was written in the 1950s to tell a story about gambling in New York City in the '20s and '30s. Because our two typefaces, King of Diamonds and Jackpot, have so much contrast, I wanted the layout to mirror this effect. I also included a couple of illustrations that bring the gambling theme to life. We're going to mix up the order of how we sketch things just a tad to accommodate for the extra elements in this composition.

1. Outline the organic shape that will fit the text, then block out where the words are going to go. I had to shift and erase a lot in this step so that the shape containing the quote fit perfectly around the blocked-off text area. The organic shape is a recurring element in some of the older vintage reference pieces, and I used an outward-outward-inward pattern when drawing the curves, making the inward curves smaller sizes. For the text, I have *luck be* in the same size and the same font style, Jackpot 1. The article *a* is going to be in a filled slab serif (as a nod to King of Diamonds, because a detailed style was too busy this time), and it will sit in the same row as *lady*. The last word, *lady*, will be the biggest and most detailed, being lettered in the Jackpot 2 style. All the words are titled for dynamic composition movement.

2. **Draw the frame and weight of the phrase.** This will help us get a sense of the gaps that are still within the layout shape. Remember to leave some space around the top and bottom of the article *a* so that we can add decorative lines. There also should be enough space between each letter to make room for the bifurcated serifs.

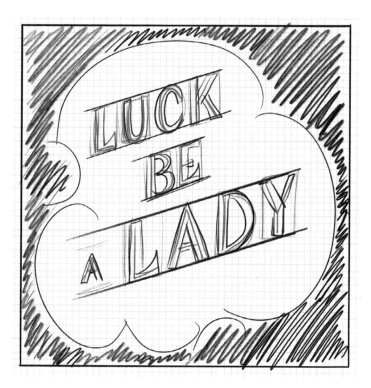

3. **Now that we have our letter placement down, we can see what areas we can still fill up with decorations and ornaments!** There's quite a lot of space on both sides of *be*, so we can add some fun icons there. I added a horseshoe and a hand of aces, but if you want, you can add dice, chips, and anything related to good luck or casinos. I also added some four-point stars to highlight our two icons. To fill in the rest of the space, I researched some vintage posters and found a style of flourishes I liked. For your layout, draw a couple of straight and curved lines around either the text or the organic layout shape. Then add dots on the ends, followed by diamonds or half diamonds on the inside. Lastly, add some curves that either touch or overlap, complete with dots on the ends of the curves.

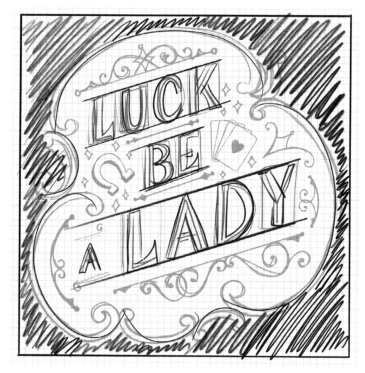

4. **Once the sketch has filled up the canvas, we're ready to complete the chapter's steps for lettering the typefaces.** Refer to pages 66 to 70 for instructions on lettering King of Diamonds, Jackpot 1, and Jackpot 2.

5. **Once you've filled in the hand-lettering portions, finalize the detailed linework around the letters.** Because there's a great deal of negative space outside of our organic shape, I added pinstripes to the background to tie the vintage casino theme together. Good luck on your layout!

THE GREATEST SHOW ON EARTH

SHOWSTOPPING LETTERS FROM VINTAGE CIRCUS POSTERS

Where can you find a ton of decorative, type-driven vintage inspiration? Circus posters! Right around the turn of the century, attention-grabbing, illustrative posters were printed with bold colors and exotic images to capture the attention of folks passing by. They promoted magic shows, carnivals, circuses, and other traveling shows. Our modern culture has extracted a whole typographical aesthetic based around the circuses of the nineteenth and twentieth centuries—including split serifs, half-and-half fills, intricate linework, dots, stars, and much more.

Expanding on Chapter 5, this chapter will also feature fonts that spilt the letters in half with dots and linework inside. We'll also be using a mix of serifs, like slab (page 66) and bifurcated (page 68). There will even be a trifurcated serif! For the chapter composition, since circus posters can get a little wordy with all the details about the show, I wanted to make sure our quote was type driven so we can practice making everything flow nicely. You'll be able to hand-letter showstopping promotional pieces of your own after this project!

CLOWN ALLEY

Our first font is a simple outlined style that's filled in with elements found on circus posters as well as in the makeup on a clown's face! The letterforms themselves have slight modulation but stay thicker throughout, giving us plenty of room to add elements in the middle. The result is a pretty whimsical font for being the basic starter for this chapter. Feel free to use a sharp pencil or small-tip pen for all these fun details.

1. Draw the frame of the letter.

2. Add the weight, keeping it fairly consistent throughout the letter.

3. Add a bifurcated serif to the ends and make sure you have a solid outline of the whole letter.

4. Finally, add the circus details! Start with a large circle in the center, then add two smaller circles on the top and bottom. Complete the look with elongated triangles on the very ends.

5. Using a pen, complete the practice letter by filling in the remaining details.

If you are using a pencil for this project, keep it pencil sharp for lettering the rest of the alphabet. Since the letters are left in outline form so that you see the details inside, feel free to grab some colored pencils to add even more excitement to your letters!

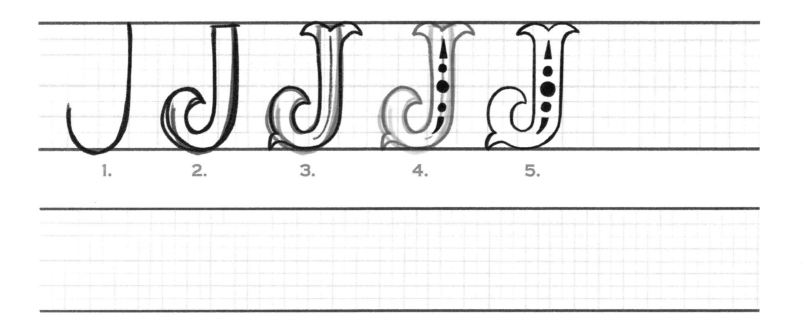

1. 2. 3. 4. 5.

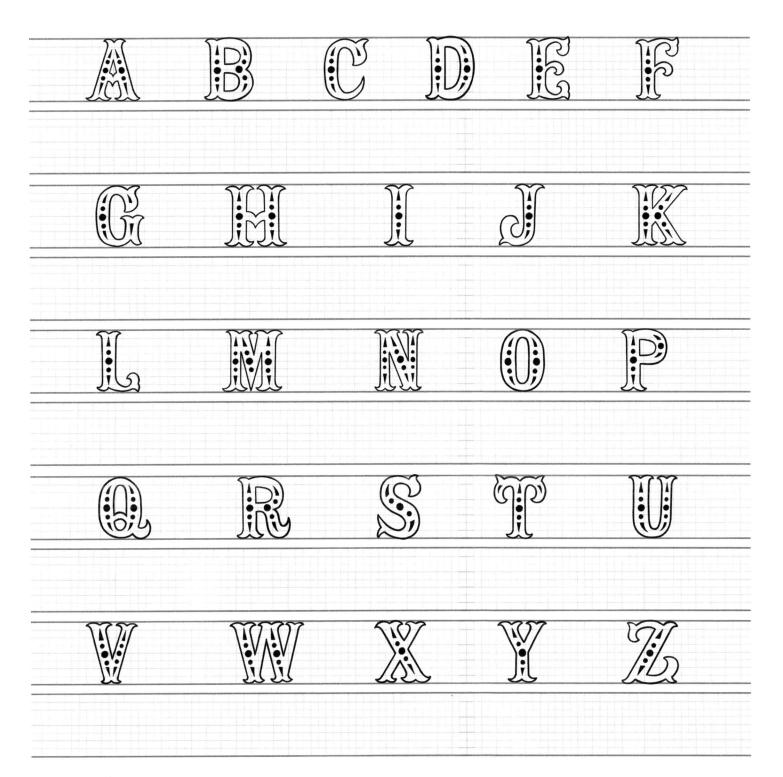

TUSCAN RINGMASTER 1 AND 2

Here are two styles that demonstrate every aspect of what makes up a display font. Display fonts or typefaces are made up of highly stylistic letterforms and make for attention-grabbing headlines, but they don't work well as body text because of their complexity.

Tuscan Ringmaster consists of two styles that are based on vintage fonts from the mid-1800s called Tuscan Ombre and Tuscan Ornate. I made some slight changes to the original fonts because we're hand-lettering these styles and not using an old printing technique. The first typeface variation (Ringmaster 1) is a half-and-half where the top is almost totally solid except for the cutout of a centered triangle, which is filled with floating stripes. It almost looks like a circus tent in the night sky! The bottom half is made up of a familiar fill: dots descending in size, downward from the center.

The serif on this one is called trifurcated because it splits into three shapes rather than just two, like a bifurcated serif. A trifurcated serif provides nice consistency in the letterform because the roundness of the serif is mimicked in the descending dots.

1. Draw the frame of the letter.

2. Add the weight and lightly sketch where the three parts of the trifurcated serifs will sit. On the L specifically, the right most third circle will sit on the end of the leg of the L all the way to the right as seen in the example image.

3. Draw the trifurcated serifs and connect them to your modulation lines. Make sure you have an open letterform to fill with details.

4. When adding the details, I use the following order: Start with the outline of the triangle shape and fill in the top. Next, I fill in the triangular cutout with lines that go all the way up the cutout. Third, I start from the center and draw out the descending solid circles.

5. Using a pen, complete the practice letter by filling in the remaining details.

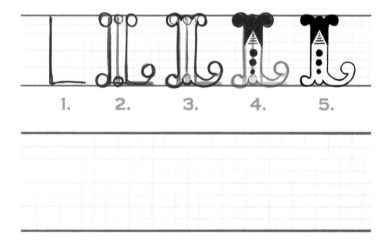

1. 2. 3. 4. 5.

Tuscan Ringmaster 2 is closely based on a typeface from the mid-1800s called Tuscan Ornate—"ornate" because it consists of so much linework. It's a good idea to bust out a small-tip pen after you've sketched the letter. I had to include this font because it's a popular vintage staple and provides great practice with all those details. Circus performers all wear extravagant costumes—I think the letters should match!

The top portion of the letter is a slab serif with straight lines to match the slabs. The letter is split in half with the outlines of circles in the middle. Lastly, the bottom stands regally with its bifurcated serif finishing and curved linework to match. Also incorporated are splash-like shapes. This is a showstopper style for sure!

1. Draw the frame of the letter.

2. Add the weight, which is almost the same throughout the letter. Be sure to include the slab serifs at the top.

3. Add the bifurcated serifs on the bottom, the circles in the middle, and the splashes on both sides of each area on the bottom.

4. Add the details. This step is all linework with the same weight of lines throughout. Draw straight lines all across the top half of the letter. Then add circles with a small accent line along the bottom of the circle. The splashes on the sides of the letter get a center line. Finally, the bottom half gets slightly curved lines for a fill. After inserting all those details, add a basic drop shadow (page 18) with a solid fill to make the letter pop!

Now you're ready to really get some linework practice in—you'll be an expert at display-styled lettering after going through this alphabet!

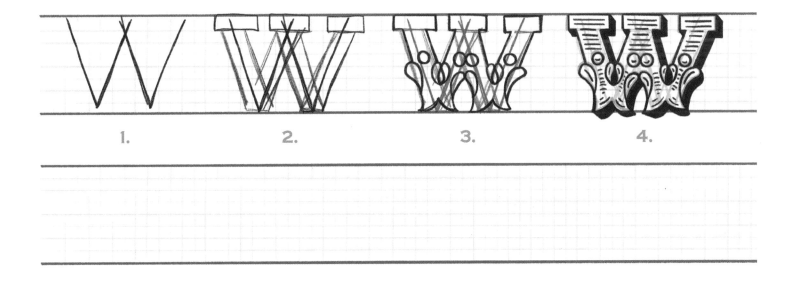

1. 2. 3. 4.

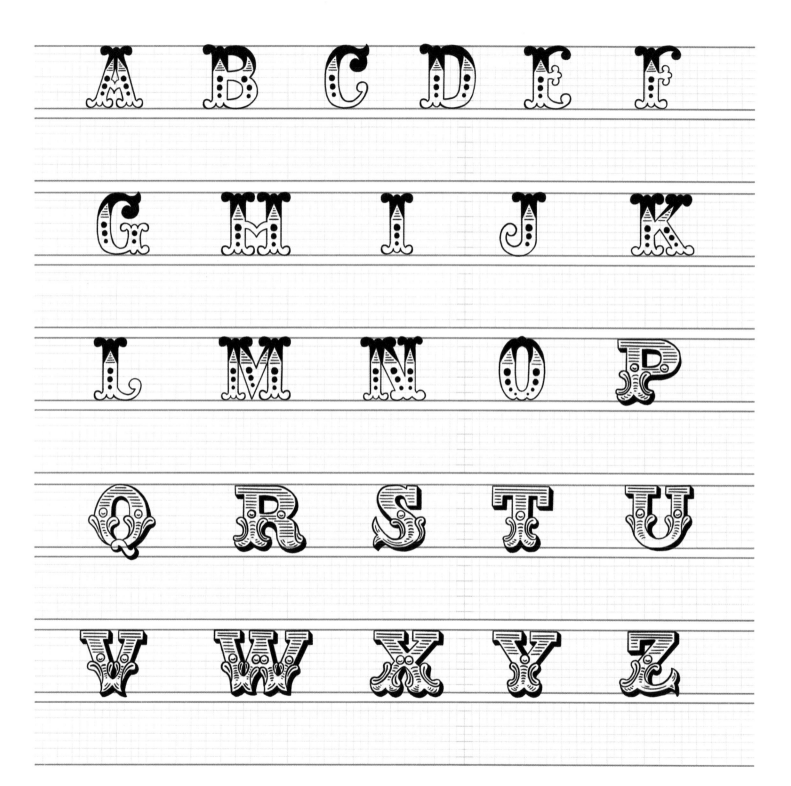

LETTERING THE COMPOSITION

We've had it fairly easy so far with short quotes so we could focus on getting the style right and the layouts filled with accents. But what happens where there are more than four or five words? To keep readers engaged, vintage typographical posters and ads change the direction of the lettering. We're going to take a look at the phrase "Welcome to the greatest show on Earth," and we'll dice it up into three parts so that the piece has a nice flow.

Welcome and *on Earth* are going to be on the same level of visual hierarchy by being in the same font style and sitting in the same arc shape (but mirrored on opposite ends). *Greatest show* is the attention grabber and will be in Tuscan Ringmaster 2 sitting on a dynamic and wavy baseline. Complex details and complex baselines result in the composition's focal point! Lastly, the least important words are *to the*, which will slide in nicely above greatest show and get the Clown Alley style.

Because this quote is a tad wordy, we'll use simple shapes and accents so we can let the details of the letters shine. These details will still tie into the circus theme, but they won't overcomplicate things, leaving us with a balanced quote. An easy way to help with legibility and to move the flow of the quote along is incorporating action lines. These lines are seen in multiple posters from the late 1800s. They can be all one weight and sit between each row of text. We'll add some circus stars in the leftover negative space.

1. **Map out where the full quote is going to go.** I started on the outside and worked my way in because *welcome* and *on Earth* are curved bookends to the piece. Once those two arcs are sketched on the top and bottom, lightly add the swooping curve of *greatest* since that will be the longest word of the piece. *Show* should be similar in height and sit right underneath. Lastly, *to the* can sneak into the remaining space and also follow the curve of greatest.

Note: *Just like the flourishes in Chapter 4, there's probably going to be a lot of sketching and erasing to make sure everything fits right in this composition, so you might flip back and forth between steps 1 and 2 here.*

2. **Add the shapes and frames of all seven words.** Again, there might be a lot of adjusting since there are so many letters in this project, but that's why the shape method helps space things out before we add all the intricate details of the circus fonts.

3. **After the composition is evenly spaced and balanced with the quote (and *welcome* matches the arc of *on Earth*), fill in the background gaps with simple details.** Decorative corners are a great way to direct the eye to the center of the page. Fill in the corners and add three splashes right above the angled edge. Make sure to keep your corners on the smaller side so that they don't become too dominant. Next, add basic action lines. You can keep it simple—all the action lines have to do is be evenly spaced between words and follow the general direction of our three largest words, *welcome*, *greatest*, and *on Earth*. Above and below *to the greatest show* there's a bit more space, so let's add a couple of swirls to the action lines.

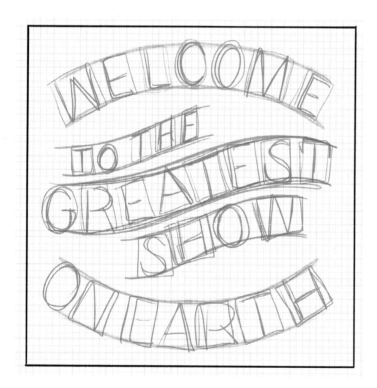

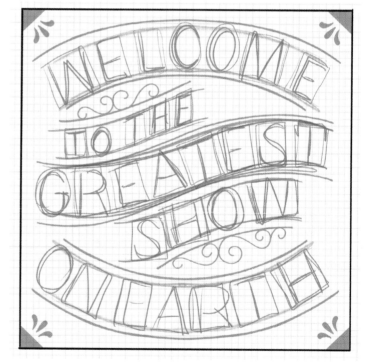

4. Fill in the details and darken the sketch. Start with the lettering portion—I usually start at the top and work my way down. Remember: frame, weight, shape, details. *Welcome* and *on Earth* are going to be in Tuscan Ringmaster 1, *to the* will be in Clown Alley, and *greatest show* gets the royal treatment with Tuscan Ringmaster 2. After filling in the lettering portion with all those fun circus details, darken your accent lines with either a pencil or pen.

5. Complete the piece with some stars. Feel free to scatter them wherever you see fit, but do not go overboard since we don't want to take the shine away from our lettering. Ta-da! A fantastical, circus-themed piece!

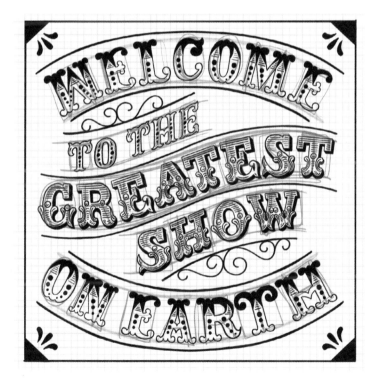

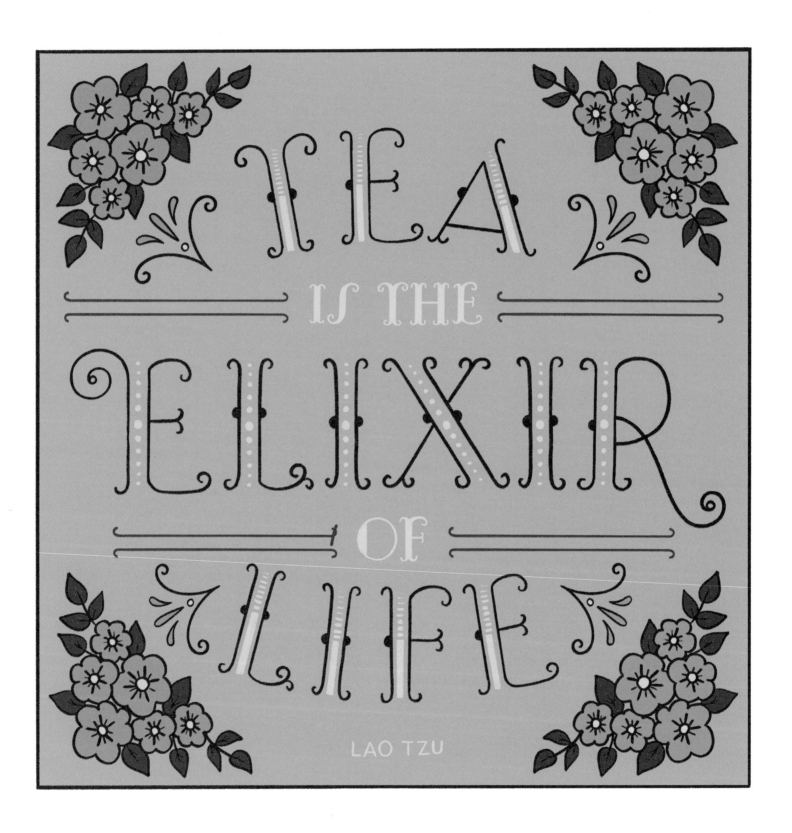

TEA
IS THE
ELIXIR
OF
LIFE

LAO TZU

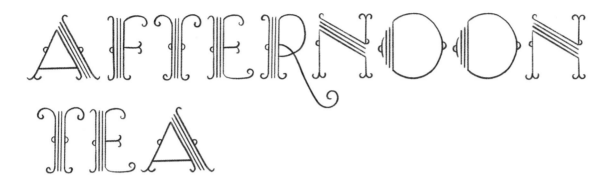

AFTERNOON TEA

AIRY DECORATIONS FOR LIGHTLY FILLED LETTERS

Afternoon tea is a ritual that started in Britain during the mid-1800s as a way to basically snack between lunch and dinner. If lunch was around noon and dinner started at 8:00 that evening, I can definitely see why people would get hungry in an eight-hour gap! Tea and pastries were served as a light meal that wouldn't spoil dinner. This ritual is still alive and well today in this chapter, with pastels and dainty details to match the aesthetic.

In the past few chapters, we've focused on attention-grabbing, bold typography with harsh contrast as a way to bring energy and loudness to our lettering. In this chapter, we'll tone things down a bit and keep our letters light and airy. Similar to past fonts, once we learn the basic style of this chapter, there will be a ton of ways to fill in the letters, so we can practice multiple versions in the second font. Our tea-centric chapter quote will bring these styles together and even introduce florals!

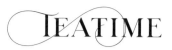TEATIME

What makes this style look so dainty is the use of negative space. Instead of outlining the full letter, carefully placed lines help with the continuity of the letterform. Continuity (when referring to the laws of Gestalt) is our brain's ability to perceive the continuation of a line with just a few visual clues, even though the full line isn't really there. Usually the Gestalt laws are taught in foundational classes of design school, but I highly recommend doing some research on your own. Nothing is as fascinating as when science meets art.

For Teatime, we are going to use an art deco style for our base, which will help guide us when adding modulation. The tops and bottoms of the modulation are going to be open so that only the sides are outlined. Within the heavier modulated areas will be a solid black bar, floating in the center. This black bar will also be our canvas for the next typeface. Finally, the look is completed with a curled split serif. You can use a thick pen or pencil for this font to help keep the weight of the linework consistent.

1. Draw the frame of the letter.

2. Add the weight, using art deco letterforms from page 43 as your guide.

3. Sketch the shape of the black bar in the middle of each area of modulation.

4. Fill in the black bar in the center of the modulation. Start to erase some of the sketch lines so that the black bar really floats in the center. Add the curled bifurcated serifs to the ends of the letters, and then the design is ready for ink.

This typeface is a fun challenge because the floating fill in the center should be even on both sides. It's a nice, meditative exercise in paying attention to details in the negative space. Grab a scone, put on a pot of tea, and enjoy your sketching!

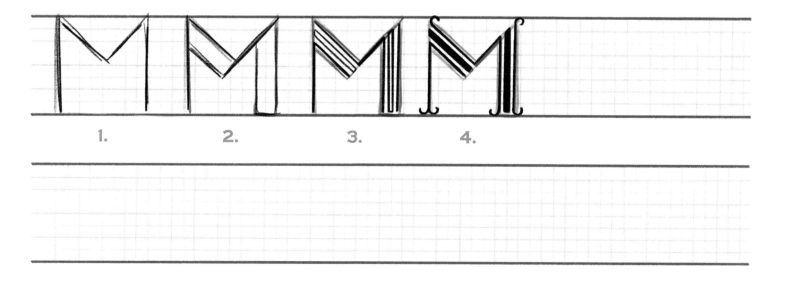

1. 2. 3. 4.

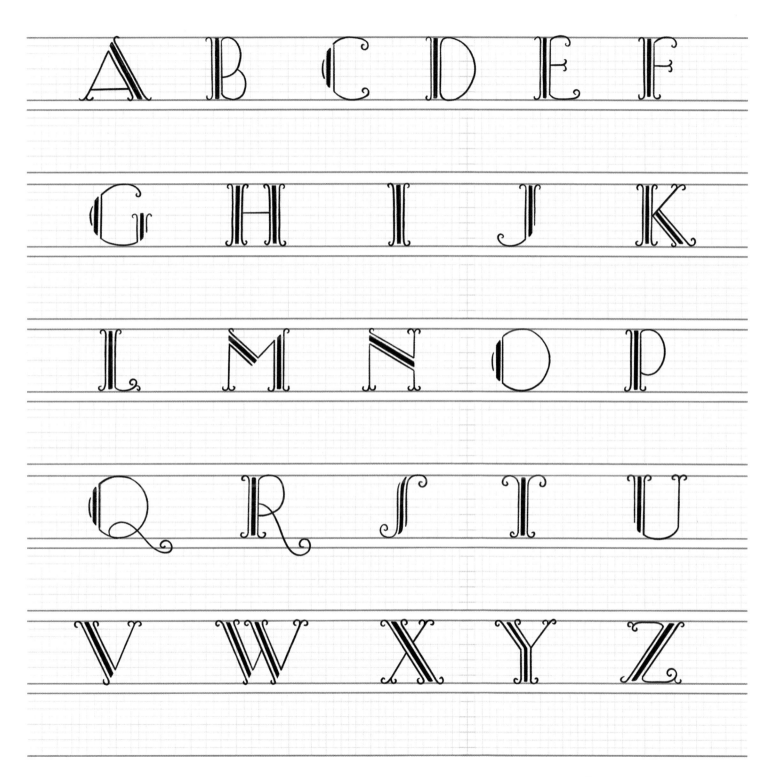

FULL-BODIED TEA

Full-bodied tea is tea that has a strong flavor, rich color, and no bitterness. There are three different variations in the Full-Bodied Tea typeface, and each has their own unique fill in the body of the letter. We're going to take a look at the last two more complicated ones, because the first style is pretty straightforward. The first variation is even airier because the black bar shape doesn't get a fill.

Let's begin with the second variation in Full-Bodied Tea, which you'll see in letters R through U in the full alphabet on page 94.

1. Draw the frame and add the weight of the letter. Also sketch out the shape where the black bar would have been in Teatime, the typeface prior to this one.

2. Fill in the black bar shape, but only halfway up. The remaining half will get lines that become lighter and lighter, like steam coming off a hot cup of tea! (Note: When drawing the stripes, start with the ones closer to the middle by applying a lot of pressure on the pencil and going over the lines again and again to make them thicker. Slowly work your way up by going over the lines fewer times and lightening the pressure on your pencil. You'll do the same once you finish your letter with darker lines.)

3. Draw the curled serifs at the ends of the letter, lightly erase sketch marks, and add half-circles to the center of the letter on the outside. It's usually common to see spurs (like those we discussed in Chapter 2 [page 33]) when adding details to the outside center of a letter, but because this type is more sweet than bitter, the smoothness of a half-circle fits in better than the harsh shape of a spur.

4. Using a pen, complete the practice letter by filling in the remaining details.

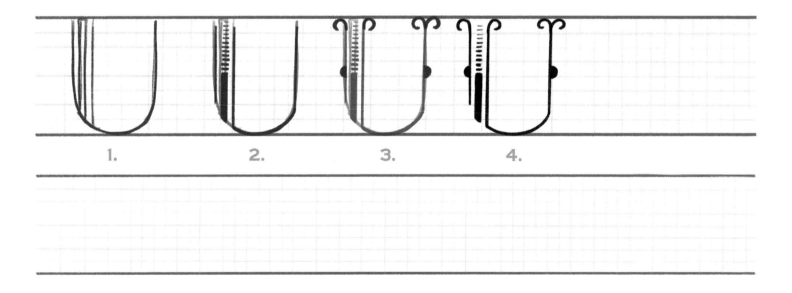

1. 2. 3. 4.

The next variation we'll go over is the third one in Full-Bodied Tea, which you can see in letters V through Z on page 94.

1. Sketch the frame and weight of the letter. Instead of drawing a whole rectangle, all you have to add is a faint center line in the modulated area.

2. Starting in the center, sketch a large filled-in circle. Continue drawing circles in descending sizes that are evenly spaced outward from the center circle. Because the circles are descending on both sides, the letter appears to have a gradient look to it, getting lighter in tone on the top and bottom.

3. Add the details. Darken the outlines, add the curled serifs, and finish with the half-circle details in the middle.

4. Using a pen, complete the practice letter by filling in the remaining details.

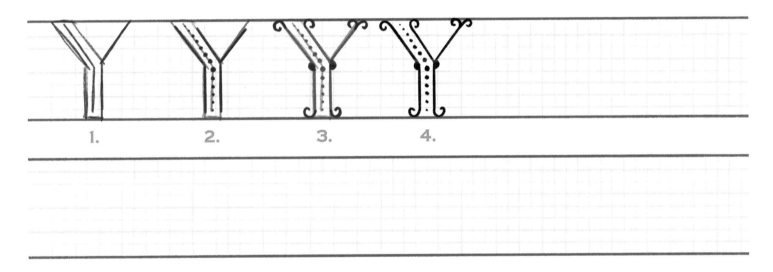

1. 2. 3. 4.

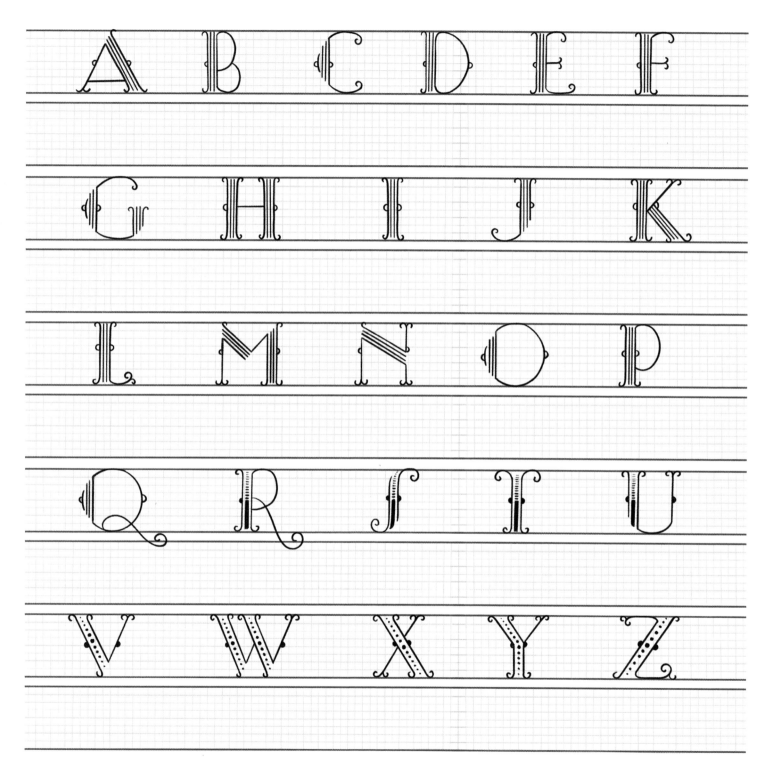

LETTERING THE COMPOSITION

While the style of the letters in this chapter has its roots in English culture, the nice thing about tea is that it's enjoyed by many cultures around the globe! Our chapter quote comes from Lao Tzu, the ancient Chinese philosopher. "Tea is the elixir of life" has a very nice pattern to it, making it easy to come up with a balanced composition.

Teatime has a feminine look and feel to it, so floral corners help tie everything together in this design and complement the organic lightness of the letterforms. Just like letters, flowers and foliage also have a very simple and similar step process: shape, frame, and details.

1. **Outline where each word will go.** Following a similar pattern to the layout in Chapter 6 (page 83), *tea* and *life* will be mirrored arcs of each other and sit in the second tier of visual hierarchy. *Elixir* will be our focal point, sitting across the center in the largest space. In the spaces above and below *elixir*, add smaller areas for *is the* and *of*. To finish off the quote, add one tiny line at the bottom center of the canvas for *Lao Tzu*.

2. Sketch the shapes and frames of each word. You don't have to fill in the attribution just yet because it is so small, so that element can remain a rectangle for now. When adding the frames of the letters, you'll notice that there's an opportunity to have balanced flourishes on the word *elixir*. Flourishes will help establish the word as the focal point even more. Add a swash to the top of the E and the leg of the R. (If you need to review swashes and flourishes, see Chapter 4 [page 53].)

3. Sketch large triangles in each corner, using the background grid to keep them even in size. These triangles will help use up some of that white space. Next, since *is the* and *of* are so small, there's also a lot of room around them. Add a long line on both sides of each phrase. Now there are just a couple of spaces we can still fill, so add curved V shapes on both sides of *tea* and *life*.

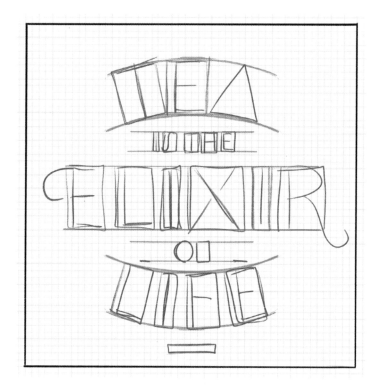

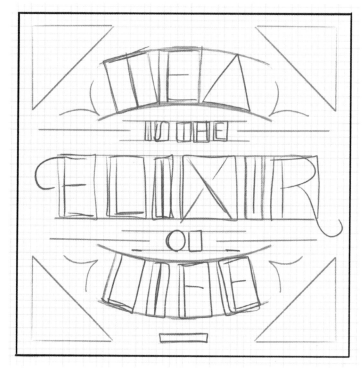

4. Before adding the type, give the sketch a few more details. In the four corners, start with a series of circles for where the flowers will go, followed by leaf shapes in the remaining gaps. This would be another good opportunity to use the tracing paper method we used in Chapter 2 (page 37) if you don't want to draw the same thing four times. The tracing paper method is quicker because it acts as a cookie cutter and allows you to replicate the design faster in each corner. Simply draw the flowers in the upper left-hand corner, then trace over the sketch on a piece of tracing paper with a pencil. Flip over the tracing paper and draw the design in the upper right-hand corner. The pressure of your pencil tip will leave markings from the reverse side of the tracing paper directly on your composition. After the four corners are filled with shapes, add the frames of the decorations within the curved V shapes.

5. By now the sketch is complete and we are ready to move on to the lettering. *Tea* and *life* will be lettered in the second style of Full-Bodied Tea. *Elixir* will be in the last style of that typeface. Because the words *is the* and *of* are so small in the composition, we will accomodate for their size by hand-lettering them in a simple variation of Teatime. Instead of leaving gaps in the center of the letterforms, simply fill them in completely. Finally, the attribution will be in a basic sans serif.

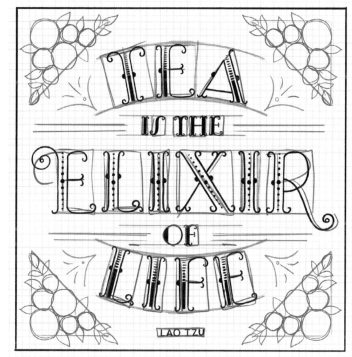

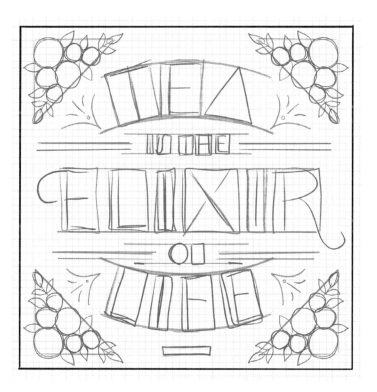

6. After the type is complete, move on to the linework. Mirroring the style of the letterforms, add two straight lines on both sides of the smaller words. Embellish the ends of the lines with a curl, matching the fonts. Next, darken the V shapes and add curled ends to those too. Complete the decorations with three splash shapes and an open dot in the middle.

7. Finally, it's time for the florals! Because the shape is already sketched out, the next step would be sketching the frame and adding details. Again, I start with the flowers. Draw a circle in the center of each flower. Next, outline the shape of each flower petal with one curved line. Finally, add detail lines outward from the flower's center and align these lines with the crease between each petal. Next come the leaves. Go over the outline of the leaf that you already sketched out. Draw a line in the center of the leaf that ends just below the top. Add two small lines connecting to the center line to represent the veins of the leaf. I think it's time to treat yourself to a spot of tea and a pastry!

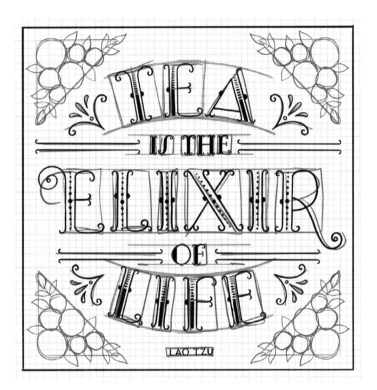

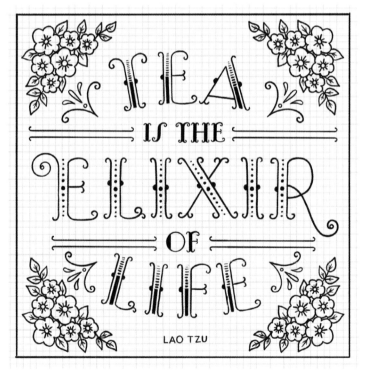

EARTH LAUGHS IN FLOWERS

RALPH WALDO EMERSON

A STROLL IN THE GARDEN

INCORPORATING A VINTAGE LETTERING STAPLE: FLORALS

A satirical TV show once instructed that if you want to make something more hipster you should "put a bird on it." Well, if you want to make your lettering as ornate as the vintage styles of the early 1900s, put a flower on it! There are many different styles of vintage-inspired lettering covered in this book, but the one thing they all have in common is how ornate and detailed they can get, especially when mixed with decorative compositions. Swirls and flourishes are probably the most common elements in vintage lettering, and they mesh naturally with illustrations of leaves, flowers, and foliage.

In this chapter, we'll get really ornate with details by adding flowers, leaves, and linework to the modulated parts of our letters. First, we'll look at a single flower with two leaves within the solid fill of a letter. Next, we'll step up our game with three flowers and more complex leaves all contained in a similar fill as Fancy Old Money (page 18) from Chapter 1. Finally, we'll bring it all together in a layout filled with blooming flowers. It might look intimidating, but I assure you, when we take the design a step at a time, it's a piece of cake!

COMING UP DAISIES

One of my favorite artists from "the sweet spot" era of inspiration (the late 1800s and early 1900s) is William Morris. He was known around the world for his complex textile designs, which always included elaborate florals and flourishes. One of the flowers that popped up in his work frequently were different types of daisies. I enjoy drawing them because they're simple and symmetrical.

To make our basic roman letters a little more interesting and organic, we're going to be adding floral embellishments. We'll use Old Money (page 16) as a base for our letterforms, but then we'll add a six-petal daisy with two simple leaves on the top and bottom of the flower. I recommend using a thicker pen or pencil to fill the letter but a fine-tipped writing instrument for the details on the leaf and flower. (Or you can use a white gel pen to go over white details in a black-filled letter.)

1. Draw the frame and add the weight.

2. Add the serif details but don't fill in the letter just yet. Draw the shapes of the daisy and leaves in the middle of the modulation. The flower fits in a circle and the leaves are in a V shape that curve inward at the top of the V.

3. When you have a basic idea of where the embellishments are going to go, add the six petals and outline the leaf shape.

4. Finally, fill in the letter with a dark solid shade and add tiny center lines to both the petals and the leaves.

Ready to see the rest of the letters in full bloom? Go ahead and hand-letter the whole alphabet in Coming Up Daisies.

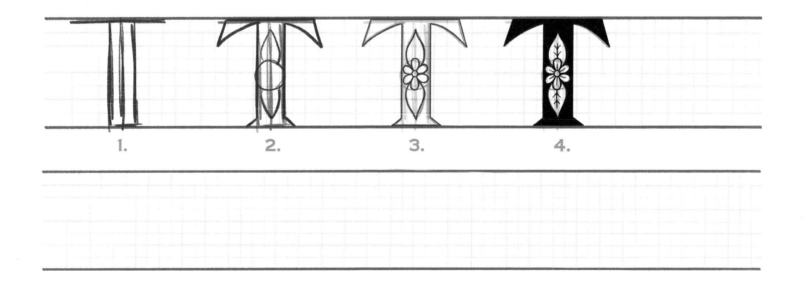

1. 2. 3. 4.

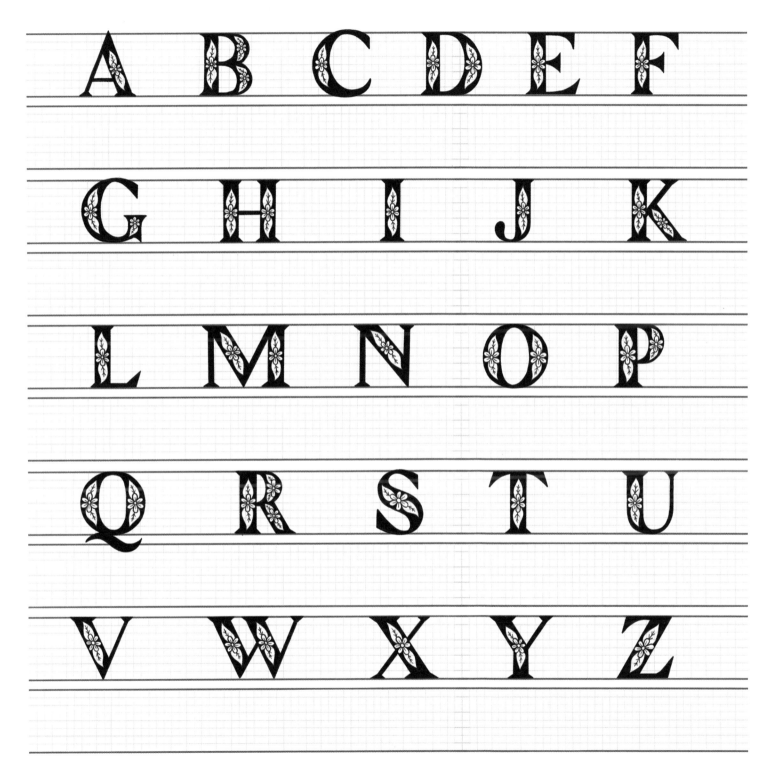

BOLD BOUQUET

When we start out with a solid-fill font, it's wise to provide a contrasting font so that the quote features a lot of variety in the layout. This next font style is perfect for such an occasion. With a highly detailed fill in the modulated area, it's a breath of fresh air to have the rest of the letter remain open and light. However, to make it pop off the page, contrast is a handy tool yet again and we'll add a solid drop shadow.

Within the detailed fill are three flowers: one large daisy from our previous font along with two smaller four-petal flowers around it. There are two leaves as well, but this time the outline of the leaves is a little more rugged to add another level of intricate detail work. The look is completed with small linework in the background of the florals. Bold Bouquet is quite the detailed display font! Be sure to start out with pencil and ink in the details with the smallest-tip pen you have.

1. Draw the frame and shape of a roman letter, similar to Old Money on page 16. Make sure the modulation is thick enough for all the details we'll be adding.

2. Add the serifs and sketch a shape within the modulated area of the letter. Add three circles for the flowers (the center one being slightly larger than the outer two) and two leaf shapes on the outsides of the circles.

3. Go over the outlines and add petals to each flower. The center one gets six and the two smaller ones get four. Also, outline the shape of the leaves with a jagged but symmetrical edge.

4. Using a small-tipped pen or freshly sharpened pencil, add the details to the flowers and leaves. Also add the background linework. For this part, I use the grid and make sure each block in the grid has the same number of lines.

5. Finally, add the drop shadow and use ink to fill in the pencil sketch.

And now for a whole garden of detailed lettering! Practice your florals and linework with all twenty-six letters.

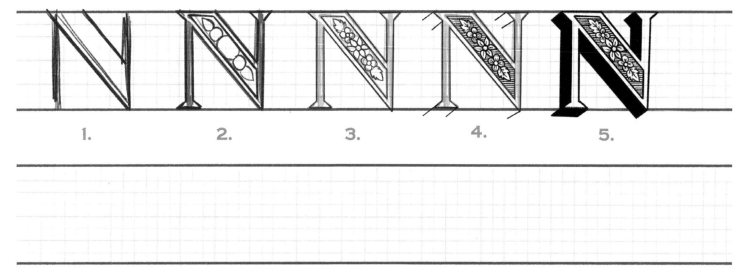

1. 2. 3. 4. 5.

A B C D E F

G H I J K

L M N O P

Q R S T U

V W X Y Z

LETTERING THE COMPOSITION

When choosing a quote to letter with flower-based fonts, I went straight to quotes by nature boy himself, Ralph Waldo Emerson. "Earth laughs in flowers" is such a beautiful quote for only being four words. It's the perfect length to get some more practice with Coming Up Daisies and Bold Bouquet, but it also leaves room for floral illustrations.

As you can see on page 102, this design is a highly detailed piece so it is going to take a lot of time to draw, but it'll be worth it—just like watching flowers grow! Once we get the lettering in place, we'll plant flowers all over the layout and add linework William Morris would be proud of.

1. **Outline where the words will go.** Because flowers and foliage are organic in nature, the layout should reflect that by avoiding a symmetrical layout. Instead, the words are going various directions, maintaining a natural look. *Flowers* is going to be the most important word, so it gets the most movement in the layout.

2. Start filling in the gaps with smaller circles, indicating where the flowers will go. When it comes to illustrating flowers in a composition, I generally stick to the magic number and feature three different flowers throughout. Like the lettering, the florals have a visual hierarchy too. The larger circles will be where the most detailed five-petal daisy will go and the smaller circles will either be twelve-petal daisies or four-petal lavender flowers. These don't have to be totally accurate right now (mine shifted a lot as I continued the lettering steps), so don't worry too much about getting this part right!

3. After getting a rough sense of where the flowers might go, continue on to the shape and frame steps of the quote. Remember to sketch very lightly in pencil in case you have to erase and adjust the lettering.

4. **Keeping up with our nature theme, swashes are a nice way to make the serifs feel more organic.** As you can see in the image, we can use some of the swashes we learned in Chapter 4 on page 54 and apply them to the E, H, L, and U for a nice mixture of top and bottom flourishes.

5. **Once the framework of the lettering is in place, add a light sketch of the flowers and leaves.** In each of the sections that have a group of flowers, I start with the larger daisy and work outward from there so that the daisy sits on the top and everything else falls behind it in order when overlapping occurs. If there's still negative space after you sketch the flowers, start to add leaves too.

6. **Add the details and finalize the lettering.** *Earth laughs* is in the Coming Up Daisies typeface, *in* is in the Old Money typeface (page 16), and *flowers* sits prominently in Bold Bouquet. Keep the quote attribution small and simple at the bottom.

7. **Add the final touches to the flowers.** I start by drawing the centers of the flowers, then I go back and add the petals, starting with the large daisies. The petals on the larger daisies can get a ragged edge to add some visual interest. Adding more details helps define that type of flower as the most prominent.

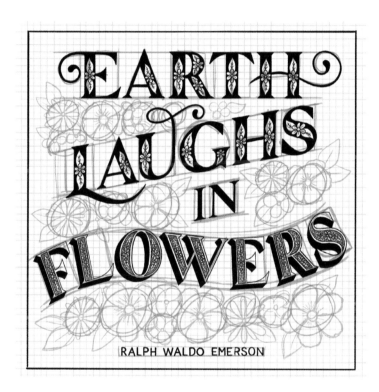

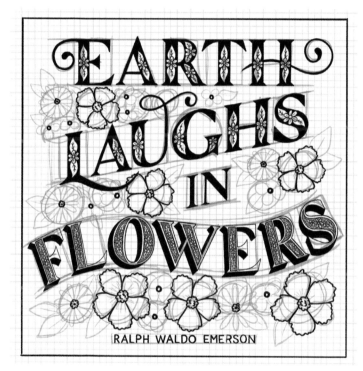

8. **Add the detailed linework to the rest of the flowers and leaves.** Use the example provided as your guide.

9. **Fill the remaining gaps.** Add some simple lines to define the shapes of the negative space around the words.

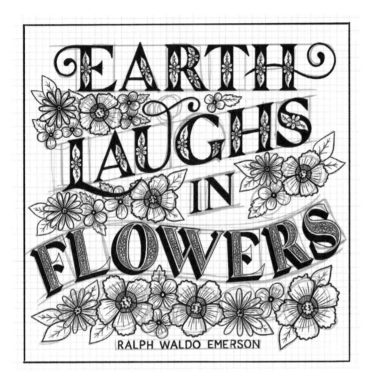

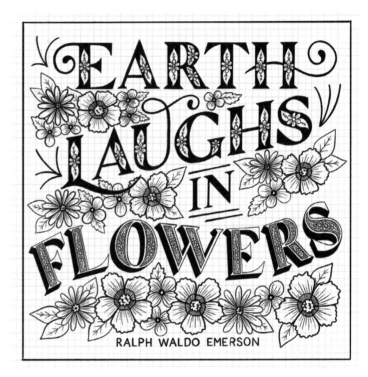

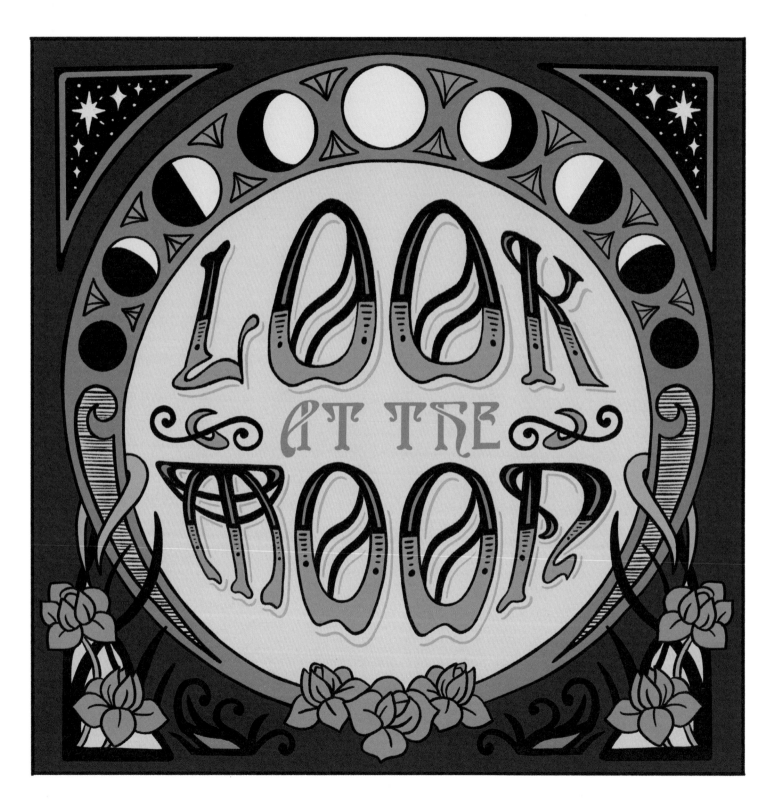

ART NOUVEAU

ORGANIC LETTERING FROM THE TURN OF THE CENTURY

Art nouveau, meaning "new art" in French, was a huge art movement in the late 1800s and early 1900s. Its distinct look took over the world by showing up in architecture, paintings, graphic design, interior design, ceramics, and much more! The style was inspired by nature and was made up almost entirely of curved lines and shapes. For further exploration of art nouveau, check out the work of Aubrey Beardsley, Alphonse Mucha, or—my favorite—William Morris.

One specific element that made the typography of this era so stylized were "whiplashed" lines. Whiplash referred to the dynamic and undulating curved lines that made up asymmetrical shapes. One look at an art nouveau–styled font and you'll know what I mean. I saved this chapter for later in the book because the letters are very organic and unstructured. I think after a few letters you'll get the hang of it, though. After practicing by lettering our chapter typefaces, Natural Whiplash and Split Beardsley, we'll throw them together in a very art nouveau composition.

Natural Whiplash

Because everything during the art nouveau movement was inspired by nature, the letters in this chapter look like vines! It's one of my favorite styles to hand-letter because it's so natural and unique and because it's easy to put your own spin on it with swashes. You might recognize some of these letterforms from psychedelic band posters of the 1960s and 1970s.

I recommend using a pencil to practice the letters until you feel comfortable with the rapidly changing modulation and foreign letterforms. Let's take a look at two very different letters.

1. Start by drawing the shape. If you're getting stuck with these newer organic shapes, be sure to pay close attention to where they fall on the grid or how far they go above and below the border (like both the A and O do).

2. Add the frame of the letter within the shape. Again, use the grid to help guide you by counting squares.

3. Add the weight of the letter. The modulation on the letters is unlike any other typeface in this book, so if you want some extra practice, trace over the printed letterforms first. This will help with both your muscle memory and hand-eye coordination, two great skills to have for lettering!

4. Next are the details, and this font definitely has some subtle ones. Be on the lookout for the curvy serifs (like on the bottom of the A and also the letter I, which looks like a bone). In some instances, where lines overlap, a white border is used to help indicate a flow to the letter.

As you can see from the demo, this style has a mind of its own. When lettering the full set of letters in Natural Whiplash, be sure to use the grid as a guide or trace over the printed letters themselves. Practice makes perfect!

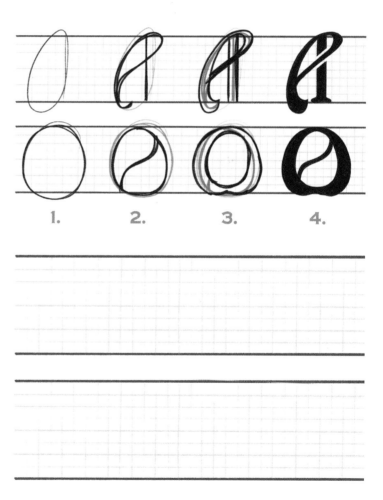

1. 2. 3. 4.

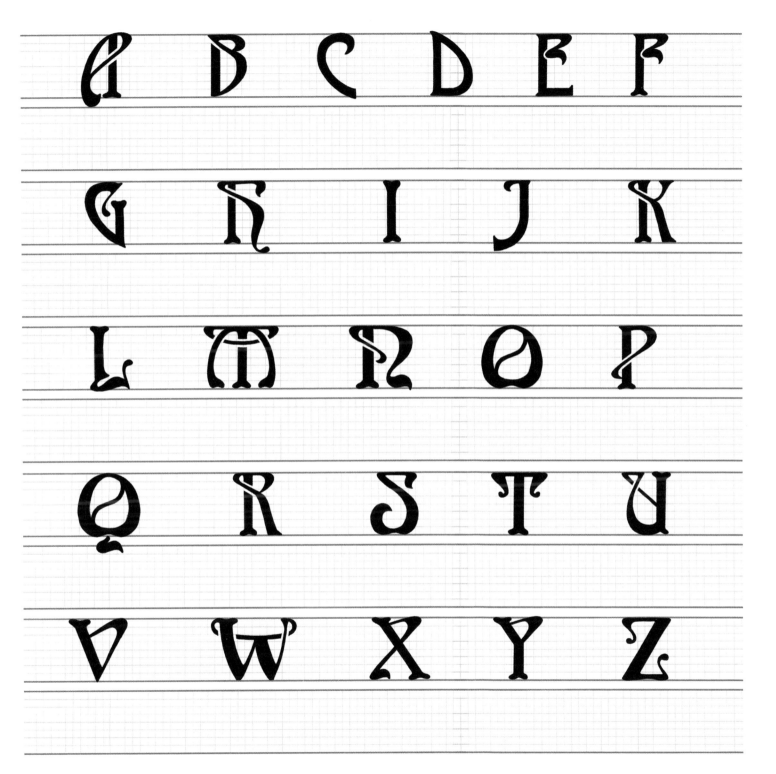

SPLIT BEARDSLEY

One of the artists I recommend checking out is Aubrey Beardsley. His artwork contained striking contrast because he always used black ink on white backgrounds. Inspired by his work, this font also is half black and half white with intricate details, as if the forms of the letter weren't difficult enough—but it's all worth it for the grand finale of the chapter composition!

1. Sketch the frame and weight of the letters you just practiced in Natural Whiplash.

2. Draw the center horizontal line, splitting the letter into two halves that will contain two separate fills.

3. The top half is going to be filled with a darker pen or pencil and have a white in-line detail. Draw the outline of the in-line detail in the modulated areas on the top half. Next, add the bottom details by sketching five lines descending in length and add solid dots to the ends.

4. Using a pen, fill in the top half of the letter and the remaining details.

5. Add a single-line drop shadow for even more intricate detail work. B for Bravo!

I love this typeface because seeing all the letters together looks moody and almost spooky. Its letterforms are truly unique and fun to draw and add details to. Take your time and enjoy sketching those ornate whiplashes!

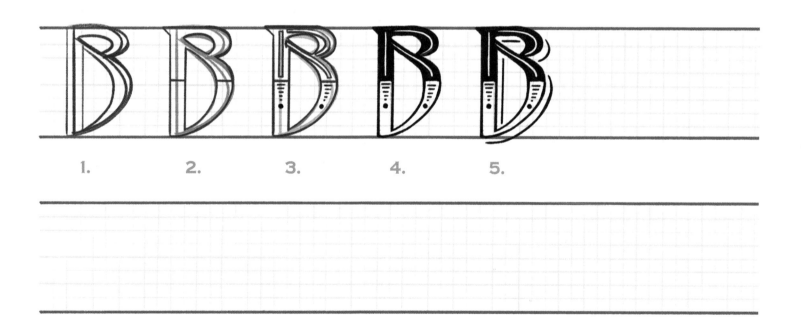

1. 2. 3. 4. 5.

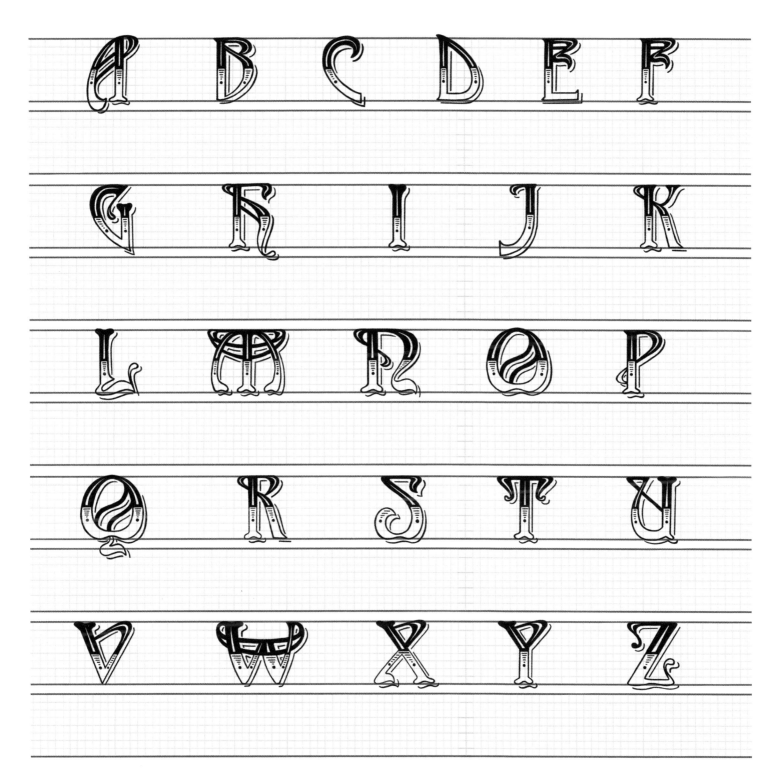

LETTERING THE COMPOSITION

Oscar Wilde was a well-known author during the art nouveau period and Aubrey Beardsley actually illustrated the artwork for his play *Salomé*, which is where this chapter's quote comes from. "Look at the moon" is a perfect line to use, especially because we can tie in another art nouveau celebrity: Alphonse Mucha. Mucha was known not only for his ornate graphics depicting beautiful women in extremely decorative floral settings but also for the halo-like forms in the background. The shape containing our quote and decked out with the phases of the moon is inspired by his halo layouts.

1. **Because this style is so shape driven, we're going to start with the background instead of the type.** Draw two circles in the middle, a large one and a smaller one inside that's positioned more toward the bottom. It might be helpful to use a compass or a couple of bowls or cups. Add a couple of triangles around the corners and then smaller circles for where some flowers will go. There will be three flowers in the center and two on both sides.

2. Add the shapes that the words will be sketched into. Since this style is all about curved lines, we'll warp the letterforms so they fit into the two halves of the circle. *At the* will be smaller and on a straight line in the middle.

3. Add the shapes and the frames of the quote. Since *look* and *moon* are going to have drop shadows, make sure you give those letters some extra room.

4. **Before we start finalizing our composition, complete the sketch by adding a few more elements.** Add stars in the upper corners. Next, draw circles inside the two center circles (for where the phases of the moon will be added). Sketch a decorative element to fill the rest of the space inside the circles. Then add more definitive lines for the flowers and petals. Finally, add swirls around the flowers and on the sides of *at the*.

5. **Time to finalize the type!** The layout is pretty challenging, so take your time and get the pencil sketch to the place you think is best, keeping an eye out for even spacing around the letters. I suggest keeping the drawing very light in case you have to erase a lot, especially when adding shadows.

6. Once the lettering is set, add all the marvelous remaining details. Feel free to experiment on your own with the art nouveau–inspired details—this style lends itself to a lot of exploration!

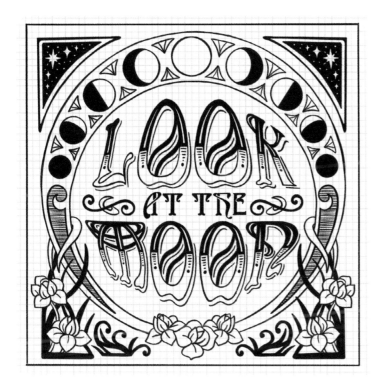

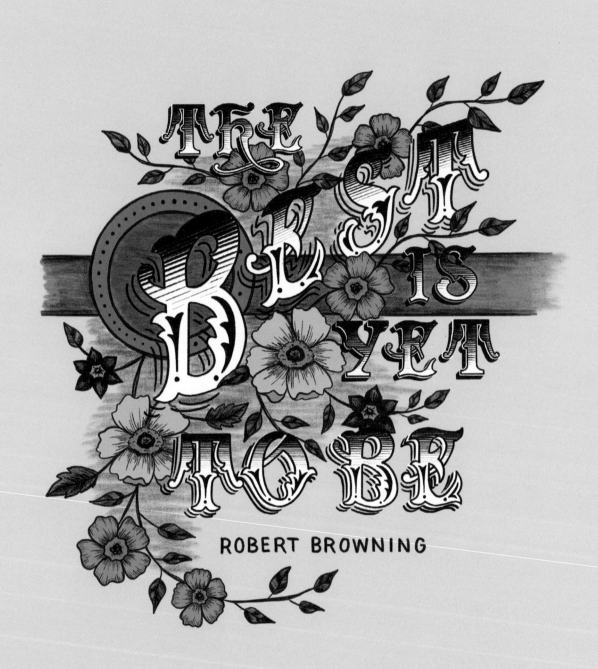

THE BEST IS YET TO BE

ROBERT BROWNING

THE GRAND VICTORIAN ERA
ORNATE DISPLAY FONTS FIT FOR A QUEEN

I've saved the best for last. Get ready to explore the fascinating detail work of the Victorian era! This is a lengthy time period spanning Queen Victoria's reign: 1837–1901. A lot happened during those years, including some major improvements to how artwork and typography was mass-printed. Before the Industrial Revolution, typography was limited to the techniques of movable type—straight lines and simple fonts. Inventions in printing during the Industrial Revolution led to typographers (or even amateurs) being able to hand-letter words and illustrate details then mass-print from the drawing directly. This is why in Victorian typography you see multiple fonts all on one page, typography on curves rather than straight lines, elaborate hand-lettering techniques, and lettering accompanied by illustrations.

The typefaces that have come out of this time period are definitely over-the-top with lavish details, ornate serifs, dramatic drop shadows, and expressive details. The advertisements created during the era were truly works of art that I draw inspiration from today. For our final chapter, we'll explore two highly detailed typefaces and then apply them to our own Victorian-inspired composition, complete with detailed floral illustrations.

VICTORIAN ROUNDED

Similar to the previous chapter on art nouveau, the Victorian letterforms might seem a little foreign at first, but the curved flourishes and rounded serifs are the elaborate details that make this style so fun to hand-letter! For this typeface, we'll be drawing some funky letters that have dramatic swashes and rounded and curved serifs. To give them Victorian details, we'll add rounded spurs in various places and then complete the fill with descending linework to mimic a gradient. You'll need a pencil and eraser to start, and then two pens—a large one for the letter outline and drop shadow and a thinner one for the inner linework.

1. Sketch the frame of the letter D.

2. Add the weight. Keep an eye on the curve of the top and bottom of the D. It's a little different than past typefaces, but again, the subtle differences are what make this perfect as a display typeface!

3. Once you have the weight sketched out, add the rounded spurs to the center of the letter, both on the left of the modulation.

4. Add a solid-fill drop shadow. Include a gap between the outline of the letter and the drop shadow. Again, it's a subtle detail, but it adds to the ornate feel of the overall letterform.

5. Fill in the detailed lines on the inside of the D. I start at the top and use the grid in the background to help me keep track of when the number of lines start to decrease and how many lines go in each square of the grid.

Helpful tip: Draw the outlines of your letters first, including the filled-in drop shadow. After that, add all those tiny lines on the inside of the letters (you can even do this while watching TV). It's helpful to do this step all at once for consistency.

Now you're ready to knock out the full alphabet of Victorian Rounded.

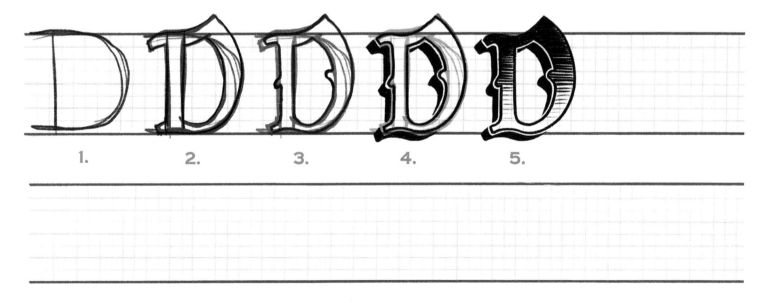

1. 2. 3. 4. 5.

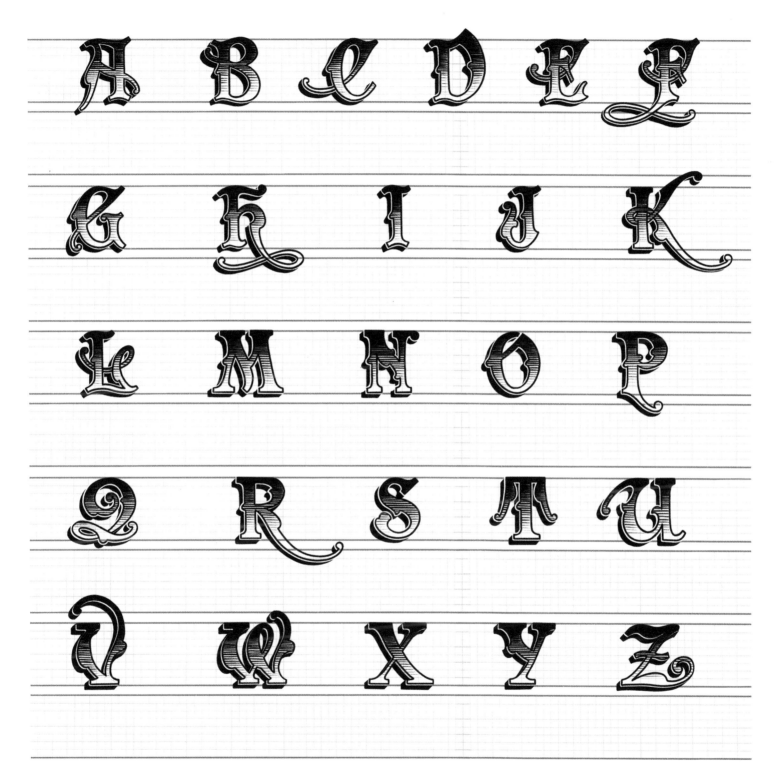

VICTORIAN POINTED

For the more detailed typeface in this chapter, we'll use the same letterforms as Victorian Rounded, but this time the spurs and serifs will be pointed to match the inner decorative elements. Because we have two very elaborate typefaces, we want to keep them relatively similar so they don't have to compete with each other to create visual tension in the composition. This visual consistency means they will complement each other in the chapter quote, but be distinct enough that you'll know which one deserves to be higher in the visual hierarchy. Let's take a look at the letter T. You will need the same materials as you used for Victorian Rounded.

1. Lightly sketch the frame of the T.

2. Add the weight. It's okay if the ends of the top of the T come to a point for right now.

3. Add the details, including a bifurcated serif at the bottom and pointed spurs in the center. At the top of the T, the details can get a little complicated, but just start on one side, adding a curve, a pointed spur, and a circle to the end, and repeat on the other side.

4. Add the drop shadow. For this treatment, start with a simple line following the outline of the letter and then add a similar one right next to it for a double drop shadow effect.

5. Add the gradient linework similar to Victorian Rounded but stop when you get to the center of the letter. For the bottom half, draw a filled-in center ornament that has a bifurcated serif at the top and a dot at the bottom.

Let's sketch the whole alphabet one last time! You're a pro now. Once you get the hang of the Victorian letterforms, feel free to test out your own ideas for swashes and inner detail work. Remember to keep the various letter widths and details consistent throughout so that your alphabet looks like a full typeface set.

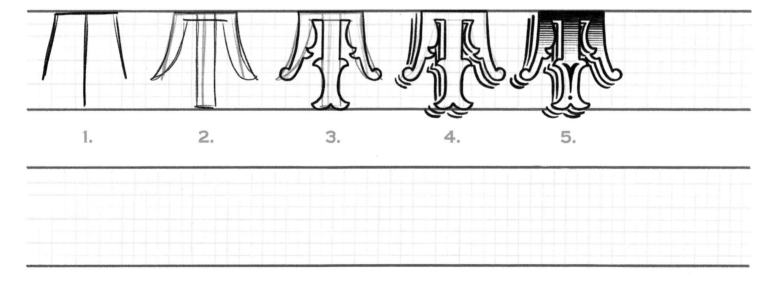

1.　　　2.　　　3.　　　4.　　　5.

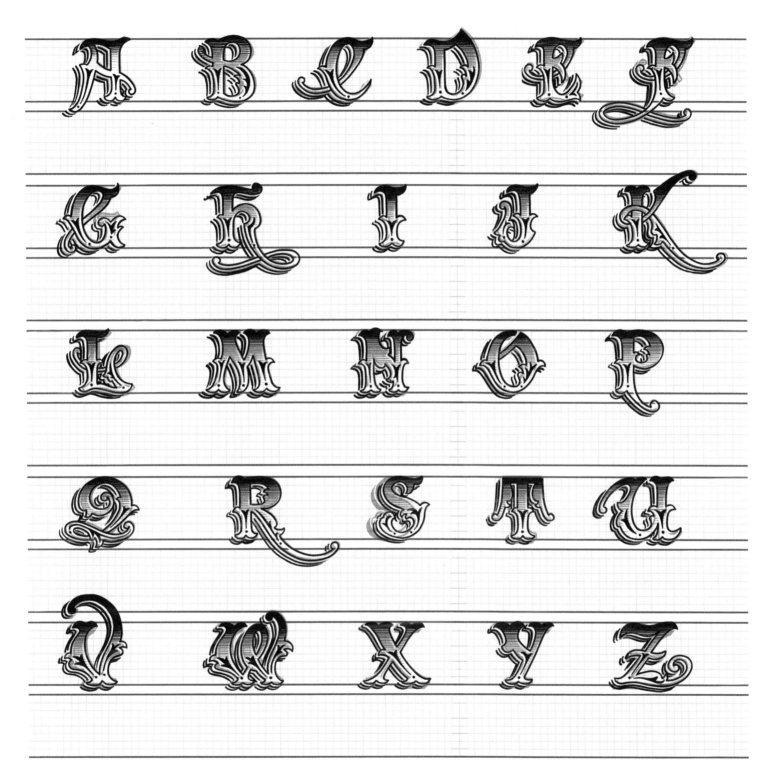

LETTERING THE COMPOSITION

The Victorian era wasn't groundbreaking only for lettering artists. Poetry underwent major changes as well, because poets were writing about new themes closely tied to the social and political trends of the times. They also explored historical themes like the glorification of old knights' tales from medieval times. One of the most well-known poets from the Victorian era was Robert Browning. He was known for his irony, dark humor, and social commentary. Browning has given us the perfect quote to wrap up a book on vintage-inspired lettering: "The best is yet to be."

While I'm absolutely obsessed with looking to the past for inspiration in lettering, I also get excited for the future because I truly believe each art project brings new learning and improvement. You, too, might have not created your best hand-lettered piece yet, but after each practice session and each composition, you get better and better. Look at how simple the first chapter's project looks in comparison to the details of this chapter composition. We've already come such a long way! Let's wrap things up with this poetic line in an ornate Victorian composition.

1. **Outline where each word of the quote is going to be.** *Best* and *to be* are going to be in Victorian Pointed and will be the largest words in the composition. In Victorian lettering, it's also common to see one word called out in a very dramatic fashion by being on a curve and having the first letter of that word exaggerated in size (almost like a drop cap). For this reason, *best* is going to be on a curve and the B is going to be a little bit bigger than the rest of the word. We can fill out the negative spaces around the curved word with the smaller words *the* and *is yet*, which will be in Victorian Rounded.

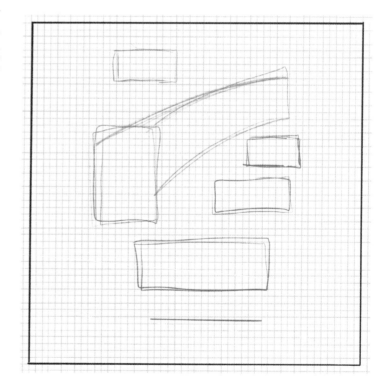

2. Sketch where the florals and foliage will go. Nothing says ornate details like some floral elements around your lettering. Plus, as we learned in Chapter 8, they're also super fun to draw! We'll also call out *best* by adding some circles behind the letter B, another composition element that's common in Victorian pieces. Start by drawing two circles in the upper part of where the B will go. Next, add a rectangular shape, almost like a flat ribbon, coming out of the circles. Finally, add various sizes of circles to represent where different flowers will be drawn, including leaves to fill in the rest of the gaps. Make sure that the flow of the flowers feels like it's all coming from the circles and follows the curve of *best*.

3. Sketch the shapes and frames of each letter. This step is a nice gut check to see how the piece is really coming together. Once you've completed this step, make sure you review your progress to see if the composition is well balanced.

4. Add the lettering details. Again, *the* and *is yet* will be in Victorian Rounded and *best* and *to be* will be in Victorian Pointed. The attribution can be left in a simple sans serif treatment. By now, you can start to see how this type of layout was great for printed advertisements. The product name was dominant on the page, while product details and taglines were wrapped around the focal point.

5. Finally, after you have the letters filled in with details, it's time to put on the finishing touches! Using a pencil, shade in the circles and background ribbon using various pressure on the pencil so that the elements are in different shades. Then, using the same flower method as described on page 111, start in the center of the flower and work your way out. Because variety is another Victorian theme, I try to use three different types of flowers per composition: a larger, more elaborate flower, happy medium-sized flowers which are used the most throughout, and then a couple of smaller flowers. Once you've completed the flowers and their details, move on to the leaves to complete the composition.

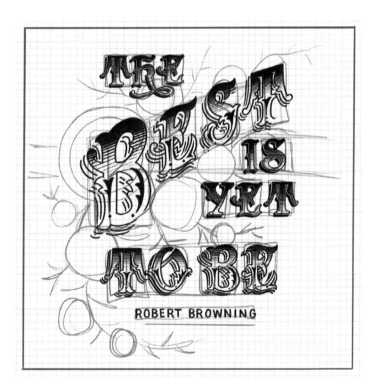

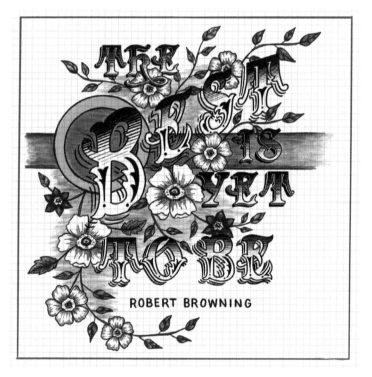

ACKNOWLEDGMENTS

I would first like to thank the artists who have shared their work and process online. When I was in my early twenties, as a typical millennial, I went to social media to learn more and more about lettering. I found an incredible community that has taught me so much more than just how to draw letters. In a way, social media is also what pushed me to look to anywhere but the internet for inspiration. I now look to old architecture, reference books, wallpaper, posters, advertisements—anything, really—for inspiration.

A huge thank-you goes out to Jason Carne for compiling the Lettering Library, an online catalog of nineteenth- and twentieth-century publications. I purchased these PDFs and they changed my life. Old books are filled with the most ornate letters I have ever seen and are my go-to when I need vintage references. For anyone in need of more inspiration, I recommend starting with the Lettering Library.

ABOUT THE AUTHOR

Lisa Quine is a creative consultant with a concentration in lettering, design, and mural services. She spent six years as an art director in the fast-paced world of advertising before leaving to start her own business doing what she loves: lettering and designing.

Lisa splits her time between painting murals, lettering for various commissioned projects, showing at art galleries, and speaking at conferences around the country. Some of her clients include Target, Kohl's, StubHub, Harley-Davidson, Hilton hotels, Lake Coloring App, Food for the Hungry, and American Greetings.

In fall 2018, Lisa was chosen by the city of Cleveland to fly to Rouen, France, and collaborate with local artists on a mural to celebrate ten years of the two cities being "sister cities."

When she's not busy painting a wall or lettering on her iPad, Lisa can be found hiking with her husband and puppies; making new friends at networking events; or, more realistically, relaxing with a good old Netflix binge.

INDEX